D1310800

IMAGES
of America

HARTFORD
VOLUME II

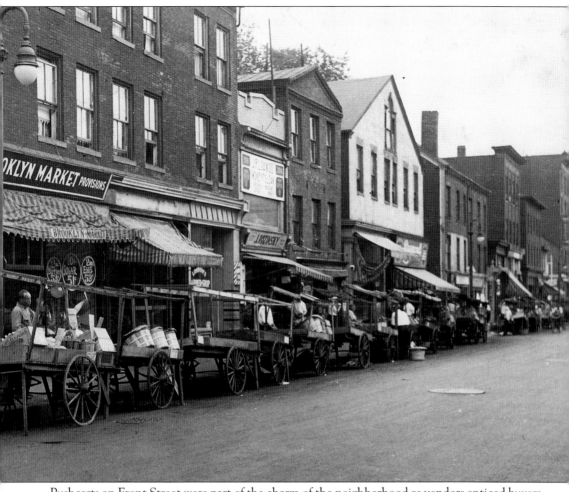

Pushcarts on Front Street were part of the charm of the neighborhood as vendors enticed buyers with products and other goodies. More than one enterprising operator began his business with a simple pushcart and expanded it into a full supermarket. (Hartford Public Library)

Cover photograph: On May 19, 1991, the Old State House celebrated its 195th birthday with a "Pachyderm Picnic." The Ringling Brothers Barnum & Bailey's "Greatest Show on Earth" sent its twenty-one elephants to the Old State House for a birthday lunch. The event also recognized P.T. Barnum's contribution to Hartford, as Barnum once served in the Old State House as a state representative. Expect more of these events in the future: this is what makes a city a city, and you certainly can't make it work in a mall. (*Journal Inquirer*)

IMAGES
of America

HARTFORD
VOLUME II

Compiled by
Wilson H. Faude

ARCADIA
PUBLISHING

Published by Arcadia Publishing
Charleston SC, Chicago IL, Portsmouth NH, San Francisco CA

Printed in the United States of America

Library of Congress Catalog Card Number: 2004100700

For all general information contact Arcadia Publishing at:
Telephone 843-853-2070
Fax 843-853-0044
E-mail sales@arcadiapublishing.com
For customer service and orders:
Toll-Free 1-888-313-2665

Visit us on the Internet at www.arcadiapublishing.com

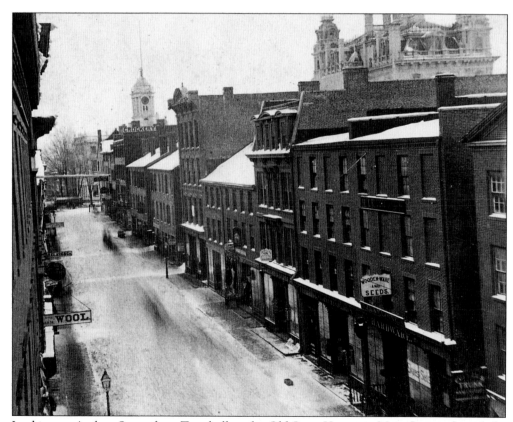

Looking up Asylum Street from Trumbull to the Old State House on Main Street after a light dusting of snow has covered the city. Merchants in the 1870s sold wool, seeds, woodenware, and crockery: Hartford was a full-service city in the nineteenth century. (Old State House)

Contents

When the Hartford *Courant* was located across from the Old State House on State Street, daily editions and news briefs were displayed in the windows. This photograph, taken in 1945, is from Tony DeBonee's excellent collection documenting our city and city life. It is a superb example of his skill and artistry and it demonstrates the importance of photography as a method of historic preservation. (DeBonee)

Introduction

Here begins *Hartford: Volume II*, with new sources of photographs and many unpublished gems which continue the story of Hartford begun in *Hartford: Volume I*. I hope it provides you with more memories, more stories, and more joy.

As this is a photograph book, I've chosen to minimize the words, preferring to share the credits and acknowledgments so the photographs can begin.

First and foremost I must thank Hartford's photographer extraordinaire, Anthony S. DeBonee. He has captured the people of our city and single-handedly created the Hartford Historical Film Society. His motto is a laudable one: "The enhancement of Hartford's heritage is a step towards its preservation." Tony continues to photograph our city and these treasured documents will become part of the Hartford Collection of the Hartford Public Library. This book marks the first time that an extensive selection of Tony's work has been presented for all to enjoy.

The second major source for this book was the Hartford Public Library. The Hartford Collection, for years under the able curatorship of Beverly Loughlin, is now in the conscientious care of Acting Curator Penny Rusnak. Stephen B. Goddard, chairman of the Second Century Fund; Robert Weinerman, president of the board; Mrs. Louise Blalock, chief librarian; and Catherine D'Italia, project coordinator of the Second Century Program, are taking heroic measures to ensure that the library and the Hartford Collection meet the challenges of today and tomorrow.

Others who have selflessly supported this volume are: Billy Kearns, a Hartford boxer, policeman, and a devoted student of its history; Paul C. Lasewicz, the archivist at Aetna who shared his priceless 1890s album and countless other treasures with me; Karin Peterson and R. Angus Murdock of The Antiquarian and Landmarks Society; Ronna Reynolds of The Bushnell; Beverly Zell and Marianne Curling of The Mark Twain House; Jo Blatti and Diana Royce of The Harriet Beecher Stowe Center; Michael Waller of the Hartford *Courant*; Christopher Powell of the *Journal Inquirer*; and Ruth Kennedy and Mary Edwards, who gave the Old State House Hartford photographs.

Lastly, this book is for the next generation; for those who will follow, and especially for Sarah, Paul, Adriana, Dylan, Kai, Aquila, Anne, Ashley, Robert, Suzanne, Camille, DeLena, Lindsay, Michael, and Venus.

It is important to note that all of the royalties accrued from the sale of this book will be shared by the Hartford Collection of the Hartford Public Library and the Old State House. In this way the present will support the past for the future.

<div align="right">

Wilson H. Faude
Executive Director
Old State House
June 1995

</div>

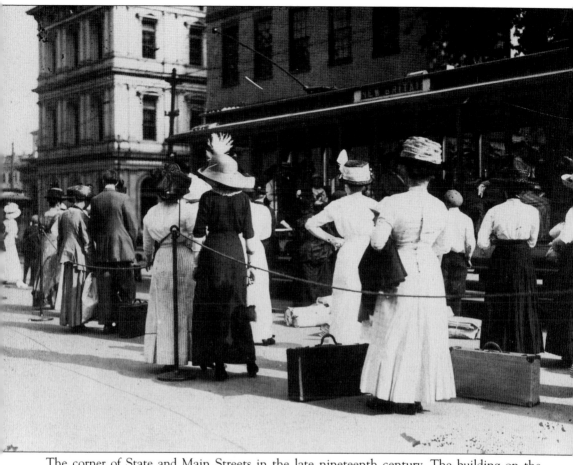

The corner of State and Main Streets in the late nineteenth century. The building on the right—currently the Old State House—is Hartford City Hall (the building was used for that purpose from 1878 to 1915). The massive building behind it is the post office, which stood on that spot from 1878 to 1934.

For nearly two hundred years people gathered at the corner of State and Main Streets and availed themselves of public transportation. In the 1890s fashionable ladies would line up for the New Britain trolley and Hartford citizens from all walks of life would pass by here at least once every day. City patterns define the character and life of a city and State and Main served as a hub, the place to catch a horse, wagon, trolley, cab, or bus until a city traffic engineer decided differently. First he moved the ever-efficient Isle of Safety and then he closed State Street. Now no one waits here for a ride. The area worked for over a century and now does not.

Let's open the street, restore the Isle of Safety, and return people and public transportation to this historic center. Even the Griffin Line should run here. It's the historic and logical center: it worked for two centuries and there is no reason it cannot work again. (Old State House)

One

The Old State House
and Main Street

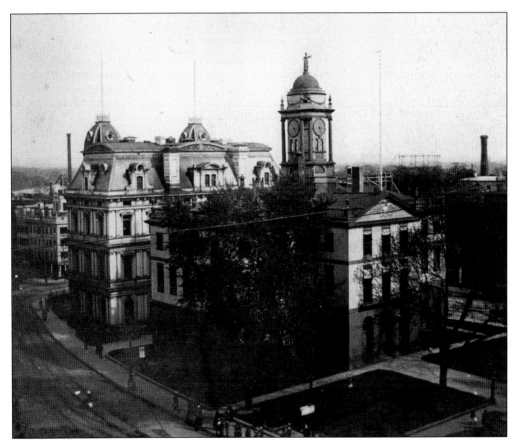

Meeting House Square has been of great importance to the city since 1636. This is where the Colony of Connecticut was founded in 1636; where the Meeting Houses of 1636 and 1720 once stood; and where the Old State House has stood since 1796.

The post office stood behind the Old State House from 1878 to 1934. The square has now been restored to its original shape, but without the old post office. (Hartford Public Library)

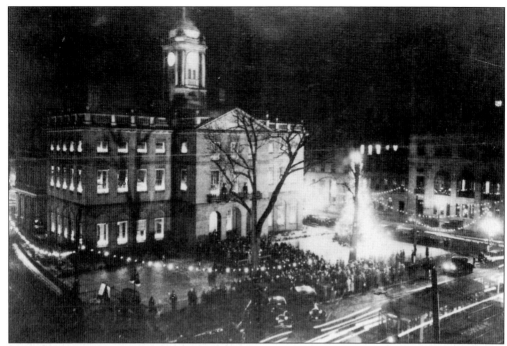

The lighting of the city Christmas tree was always a festive occasion when the Old State House served as city hall. (Old State House)

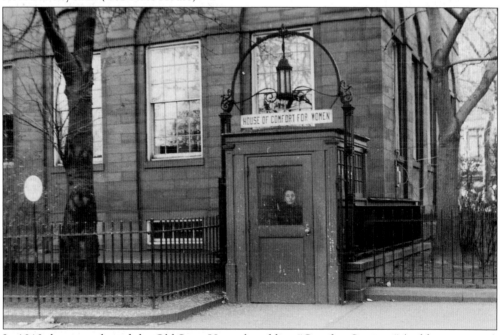

In 1913 the city enlarged the Old State House by adding "Comfort Stations" (public restrooms) under the east side of the building. On the south was the "House of Comfort" for men, on the north, the one for women. The "Houses of Comfort" operated until the 1960s, when, having become dens of inequity, they were finally closed. They were demolished in the 1970s. (Old State House)

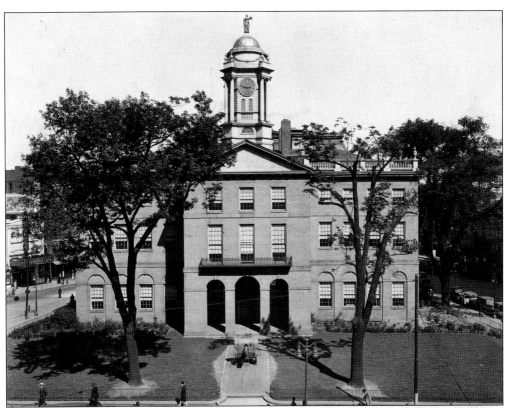

After World War I, the Old State House served as a community center and the classic "field artillery trophy" ornamented the Main Street walk. Eventually it disappeared. Today a Revolutionary bronze cannon is fired daily by the uniformed guards as a salute to the first meeting between George Washington and the French armies in America. (Hartford Public Library)

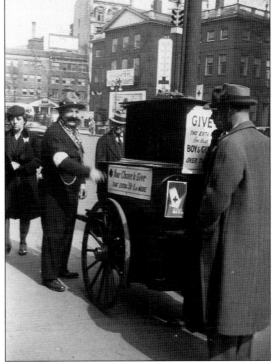

"Columbo," Hartford's hurdy-gurdy man, poses on Main Street in March 1945. When each donation was made to the Red Cross, the crank would turn and the organ would fill the air with music. (DeBonee)

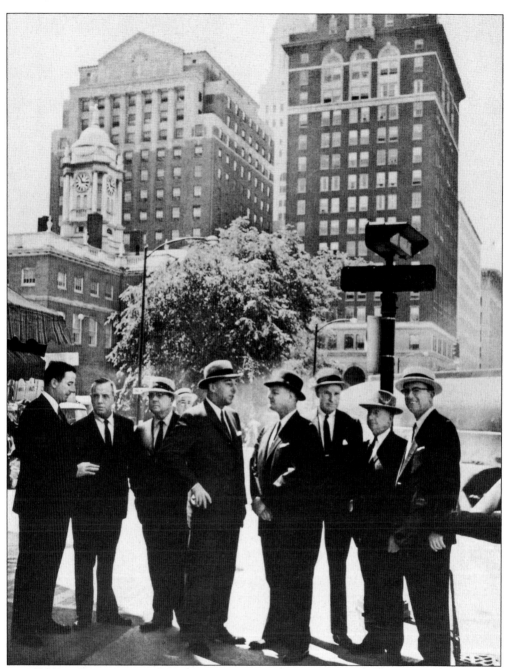

Long before there were "Bishops," corporate chieftains dominated the Hartford scene. *Look Magazine* assembled a few of them—the presidents of eight insurance companies—for a photo opportunity for this 1960 issue. Gathered at the corner of State and Main Streets are, from left to right: John Alsop (Mutual of Hartford); E. Clayton Gengras (Security-Connecticut Group); Frazar B. Wilde (Connecticut General); Charles J. Zimmerman (Connecticut Mutual); John A. North (Phoenix of Hartford); Lyman B. Brainerd (The Hartford Steam Boiler Inspection and Insurance Company); Benjamin L. Holland (Phoenix Mutual); and Henry S. Beers (Aetna Life Affiliated). (Old State House)

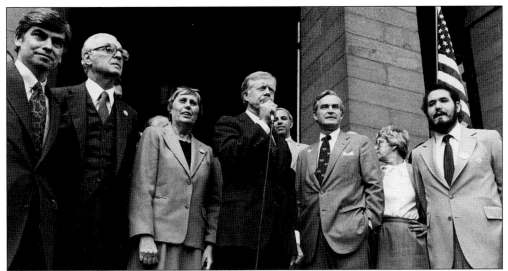

From the time of Washington to the present day presidents have visited and campaigned from this site. On October 16, 1980, President Jimmy Carter visited the Old State House and, as a campaign gift, presented the submarine USS *Nautilus* to the State of Connecticut. Accompanying the president on that visit were, from left to right, Senator Dodd, Senator Ribicoff, Governor Grasso, President Carter, Stanley Schultz, Wilson Wilde, and Patty Kane. (Old State House)

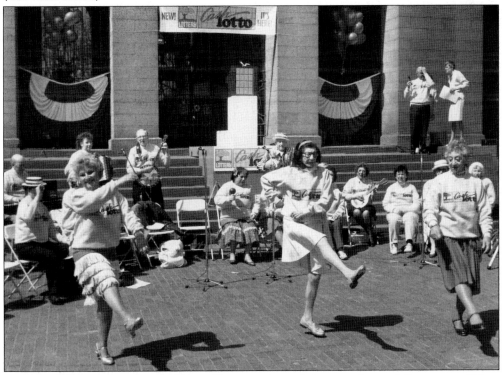

"Never a dull moment" is an Old State House credo, and there rarely is a dull moment. When Connecticut created "Cash Lotto" on April 6, 1992, high steppers launched the event with vintage gusto. (Old State House)

13

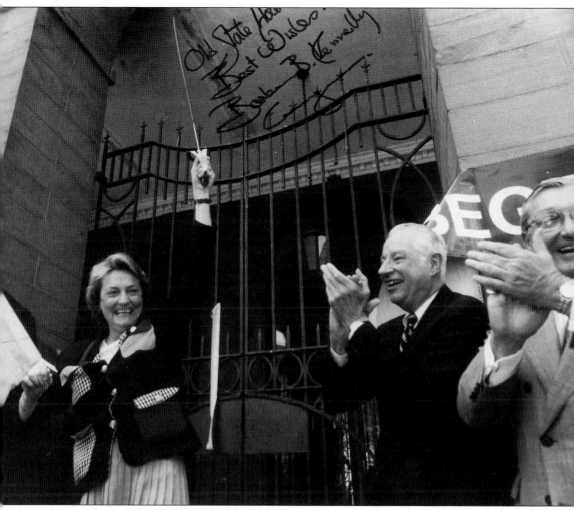

Historic beginnings are heroic events. On May 22, 1992, Congresswoman Barbara B. Kennelly, using a great sabre, cut the "Let the Renovation Begin" ribbon. Beside her (to the right) are Robert Ewing (president of The Connecticut Historical Society) and David L. Coffin (chairman of the Old State House). The society will operate a Museum of Connecticut History in the new gallery, constructed underground as part of the renovation project. The massive renovations made to the building structurally saved the landmark and made it accessible to all.

As a member of Hartford's council in 1975, Mrs. Kennelly helped save the Old State House from the demolition advocated by other council members and even by the chamber of commerce, who wanted another parking lot. Later she would use her leadership to secure the ninety-nine-year lease for the building from the city, and to secure federal funds for renovations. She has been a best friend in all seasons.

The renovations were needed to stabilize the building, restore the chambers, and get the landmark properly ready for its 200th birthday in May 1996. As "Connecticut's Single Most Important Building," it will soon be ready to meet the challenges that its third century will surely present. (Sherry Peters, Hartford *Courant*)

14

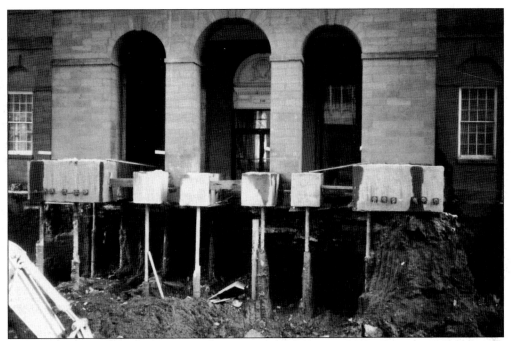

As part of the renovation process a new foundation resting on bedrock was required. During the winter of 1993 the Main Street portico of the Old State House was held up by compression blocks while the shifting foundation blocks were removed and new footings were installed. (Old State House)

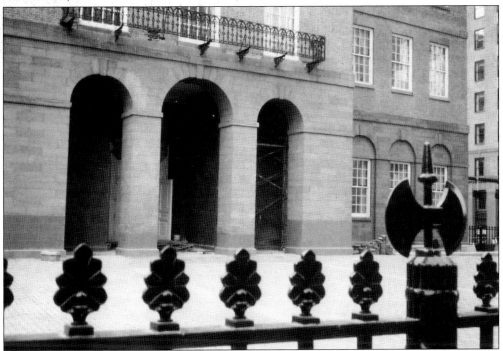

By the spring of 1995 the Main Street entrance was back in place, with no one suspecting the Herculean effort that had taken place. (Old State House)

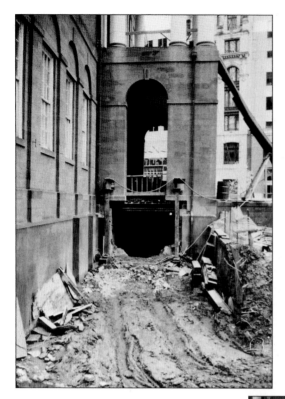

The great east portico was suspended on steel beams while new supports and foundations were installed. Newfield Construction of Hartford ably oversaw the work as the general contractor. (Old State House)

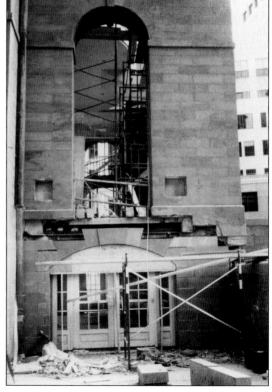

By the spring of 1995 the east portico was returning to normal but with a new entrance more accessible to all. The new steel and foundation work which had allowed the portico to be restored to its original state has been cleverly hidden from the visitor. (Old State House)

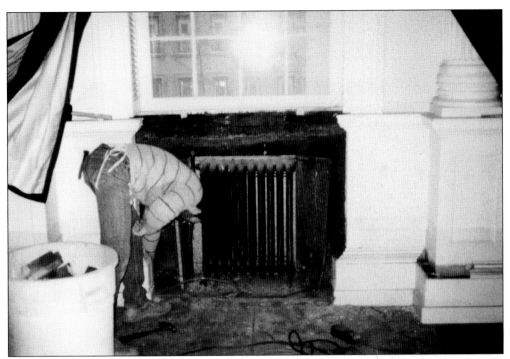

In the 1880s radiators were added beneath the windows of the senate chamber. When 1995 renovations were being planned it was decided to restore the room to its original (1796) state. This photograph shows a workman removing the encasing woodwork so the radiators can be removed. (Old State House)

The radiators have been removed, the woodwork has been restored, and the great senate chamber merely awaits the return of Gilbert Stuart's original portrait of Washington to cover the shuttered center window as it did in 1801. It is the only one of Stuart's portraits of Washington to hang in the setting for which it was originally commissioned. Much of the original furniture, rescued by Newton Brainard in 1959, will be returned to the senate when the renovations are complete. This photograph allows us to see why the senate chamber has been called "One of the ten most beautiful rooms in America." (Old State House)

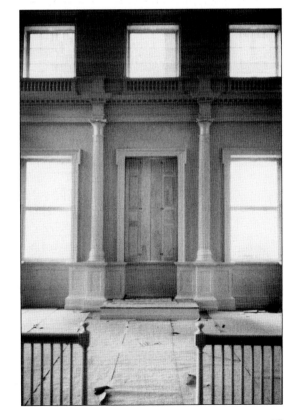

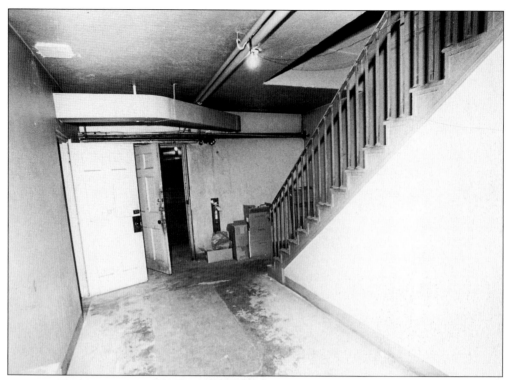

A basement was added to the Old State House in the 1880s. It was, even after the 1970s renovation, a basement of curious chambers most unbecoming to the building. (Old State House)

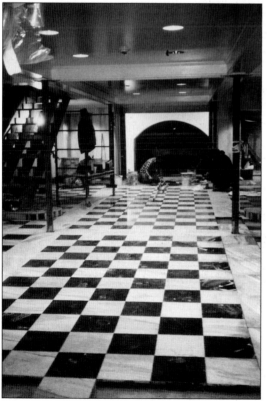

In 1995 the rabbit warren of basement chambers was demolished and the former basement was transformed into a proper entrance space. (Old State House)

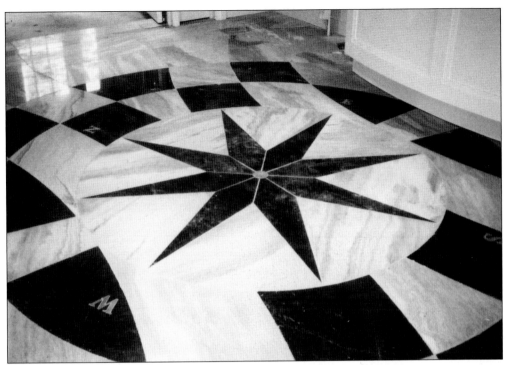

In the center of the floor of the new east entrance is a star. Set as a compass, its center has the brass disc that marks the spot from which all milestones in Connecticut are measured. For example, Four Mile Road in West Hartford is exactly four miles from here. This is the spot. This is ground zero. (Old State House)

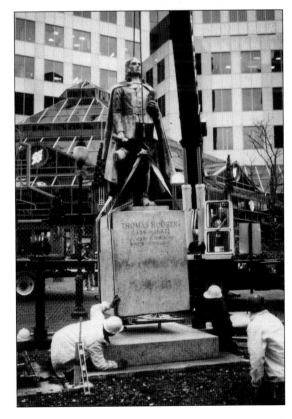

On October 22, 1992, the statue of Connecticut's founder, Reverend Thomas Hooker, left the square to take a temporary home in storage and the renovations began in earnest. On December 7, 1994, Hooker returned just as the final stages of the work were being completed. So much dirt, so much work: all to be a distant memory when the landmark reopens in April 1996. (Old State House)

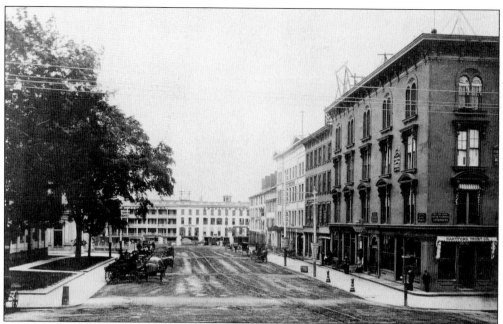

Just south of the Old State House is Central Row, one of Hartford's earliest streets. The markets of Colonial times were held here. This photograph was taken looking east from Main Street toward the American Hotel on American Row. Phoenix Home Life's home office is now located on the site of the old American Hotel. (Hartford Public Library)

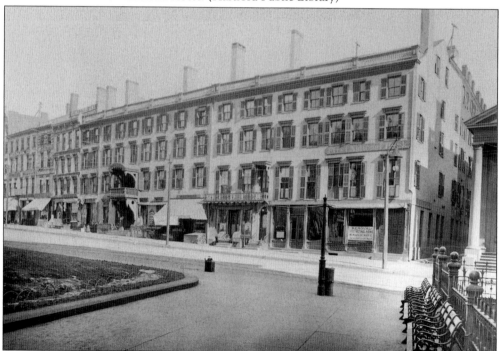

North of the Old State House is State Street, which was set out in Colonial times as the primary road from the river to Meeting House Square. Shown here is the US Hotel, much of which was demolished in April 1897 for an early Urban Renewal project. (Aetna)

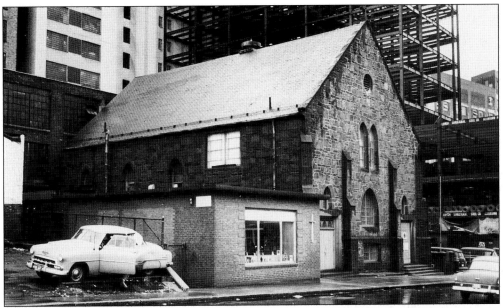

On Market Street stands the 1855 St. Paul's Church. Begun as an Episcopal Mission, it was sold in 1880 to the Lutheran Church to meet the needs of the influx of German immigrants to the neighborhood. In 1898 it was reconsecrated as St. Anthony's Roman Catholic Church. On the northern corner of the building are the graves of Dr. Norman Morrison (1706–1795) and his son, who died of smallpox in 1759. The city refused to allow the child to be buried in the city burying ground so his father buried him in the orchard behind his house; later, Dr. Morrison would also be buried there. Morrison's grandson placed a deed restriction on the land that required the continual preservation of the graves and this restriction has preserved the site from development on a grand scale. The church is now the Catholic Book Store. In this 1950s photograph we can also see work taking place on the enlargement of G. Fox & Co., Hartford's great department store. (Hartford Public Library)

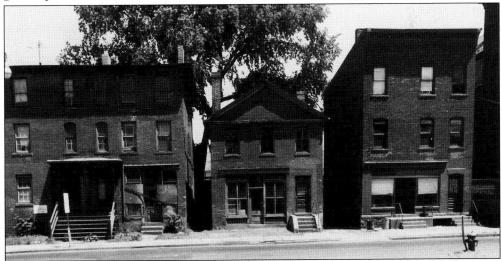

Also on Market Street were single family homes, apartment buildings with small businesses on the first floor, and two family homes. It was a neighborhood of people and businesses. It was wiped out for Constitution Plaza. (Hartford Public Library)

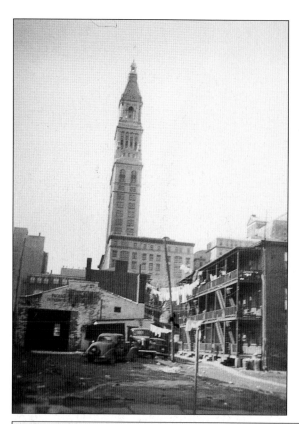

From Front Street one had this view of the backs of the houses and The Travelers Tower. (DeBonee)

Watchels, the "live-wire department store," offered free parking to attract customers to its Front Street location. Visitors to Hartford expect that when they come to the city they have to pay for parking, as they would in any city. The natives expect free parking, so in order to attract local shoppers merchants offered discounted or free parking for decades. (Hartford Public Library)

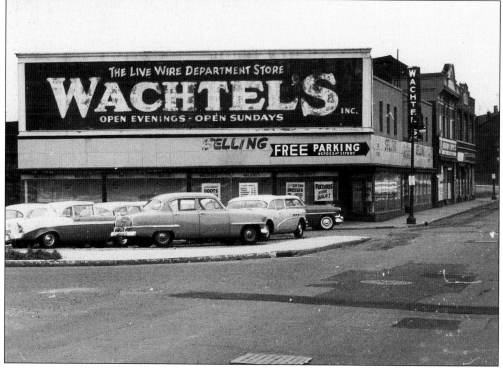

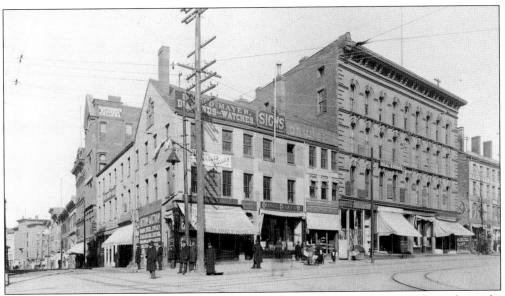

The corner of Main and Asylum Streets in March 1897. The merchants in the eighteenth-century Catlin Building advertised on the awnings, on the walls, and even on the roof to attract business. The building was demolished in April 1897 and replaced by a new Catlin Building. The new building was then razed in 1911 and replaced by the Hartford-Aetna Realty Building, Hartford's first skyscraper. Despite great protest that building was finally demolished in 1990—for yet another parking lot. (Aetna)

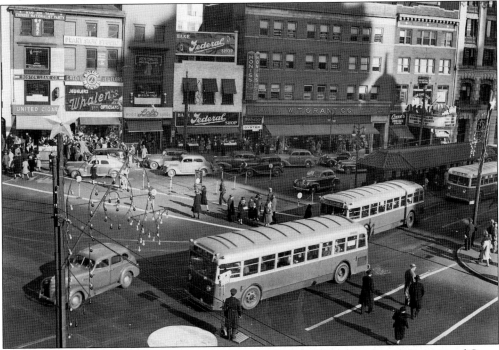

The corner of State and Main Streets at Christmas. The Regal Theatre, Anne's Dresses and Coats Store, W.T. Grants, Honiss's, the Federal Bakery, Loft's Candy Shop, and Whalen's filled upper State Street, while the lone traffic cop kept everything moving. (Hartford Public Library)

In the 1940s Main Street was filled with people, newsstands, and activities. These photographs show: (top left) Yvette Gaudette posed with Johnny, the "Philip Morris" pitchman; (top right) WTIC Radio performer Harry "Bateese" Crimi; (bottom left) Joey Armentano posing by the newsstand at the corner of State and Main Streets. (DeBonee)

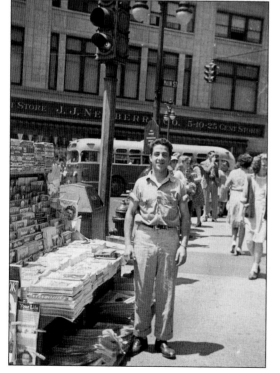

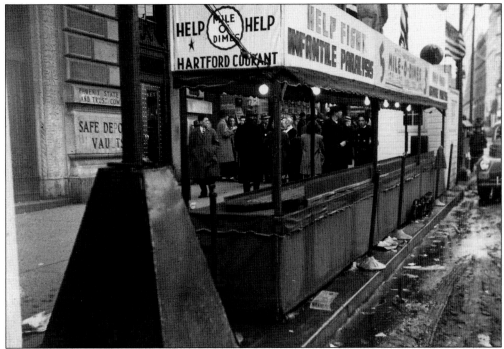

Before the United Way existed, each charity, health care, and health-related cause competed separately for funds. One of the most memorable was the March of Dimes' "Mile of Dimes" campaign. Passersby would contribute dimes by placing them in the grooved slots that were measured into miles. This photograph shows the "Mile of Dimes" on Main Street in 1946. As a publicity stunt a helicopter (courtesy of the government) dropped into Bushnell Park to pick up the donations. (DeBonee)

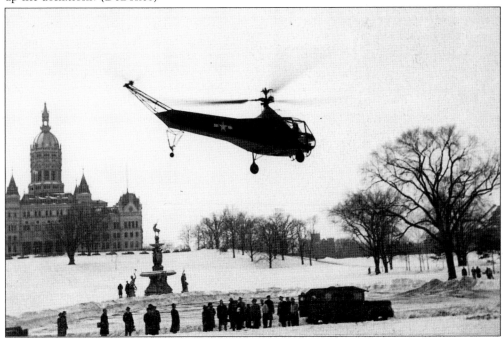

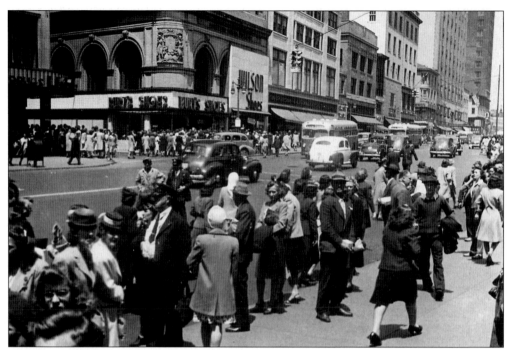

When spring arrived shoppers would hit Main Street and the retail district with a passion. From the Old State House on Main Street one could see Wilson Shoes on the corner of Asylum Street and, further up, Steiger's and Korvette's. (DeBonee)

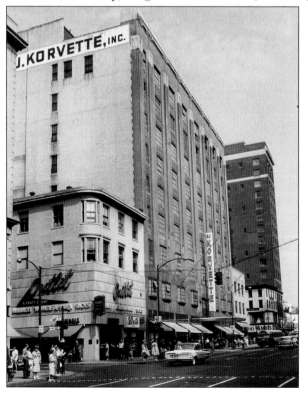

Albert's Women's and Shoe Store used to stand at the corner of Pratt and Main Streets, where the Pelican sells similar goods today. A 1979 facelift masked the Art Deco decoration and today the building is known as the American Airlines Building in honor of the anchor tenant. (Hartford Public Library)

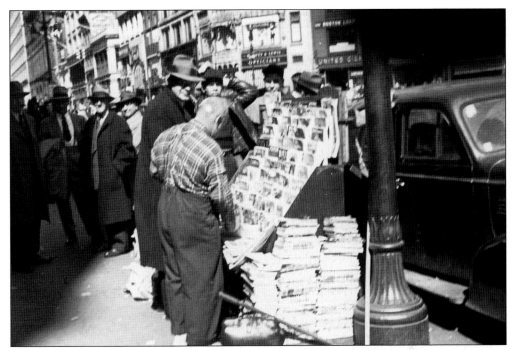

Eccentrics are always a part of a city. Some sing, some dance, and some preach. For many years Hartford's eccentric was Dan "the barefoot man" Sugarman, who was given that name because he never wore shoes, winter or summer. (DeBonee)

At the south corner of Temple and Main Streets stood the Dillon-Worth Building and its fantastic "double wizard" that perched on the corner and held up the upper floors. Completed in 1893 for Raphael Ballerstein's Millinery Shop, it was razed by the Cleveland Wrecking Co. to make way for the faceless Lerner Shop Building that remains there to this day. (Hartford Public Library)

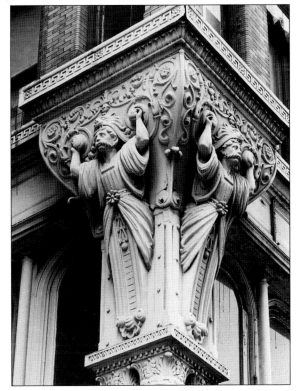

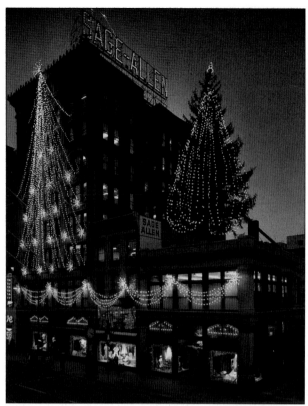

Sage-Allen lit up the retail sky for the holidays on December 12, 1955, before it received its facelift. Every store had its own theme for holiday displays. G. Fox & Co. had the Colonial Village on its marquee and priceless art from the Wadsworth Atheneum that told the story of Christmas. Sage Allen's windows told a story, from left to right, usually about a family shopping, wrapping gifts, celebrating with friends, and then unwrapping and being ecstatic with gifts bought from—guess where! (Hartford Public Library)

The Pilgard Building at the corner of Morgan and Main Streets was one of the landmarks demolished when I-84 was built. (Hartford Public Library)

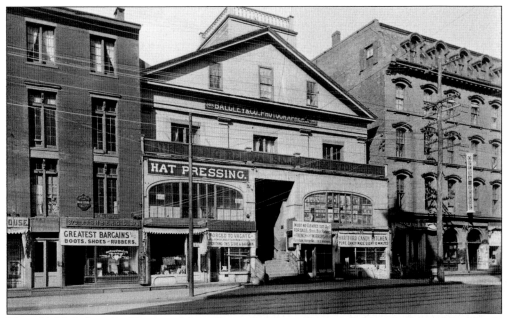

The old Melodian Building on Main Street (between Pratt and Church Streets) in March 1897. The building was torn down in April of that year to make way for the new Wise-Smith/Korvette's/American Airlines Building. (Aetna)

A view of Temple Street looking west towards Main Street and the old Melodian Building. Henry Hobson Richardson's great retail complex for Cheney Silk of Manchester, Connecticut, is on the corner. The complex later became Brown Thomson's. Today under Phil Schonberger one can look for the rejuvenation of this landmark. The structures to the right of "The Richardson" were demolished in March 1894. (Aetna)

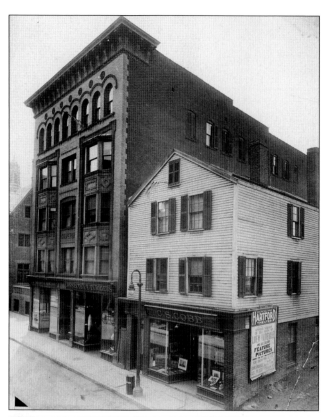

Church Street, just west of Christ Church Cathedral, was once a retail shopping area featuring businesses such as Connecticut Furriers and C.S. Cobb. In 1918 the plan to widen the street meant that 15 feet was literally removed from the front of each building. (Hartford Public Library)

Main Street north of Church was filled with eighteenth-century houses that were converted to offices. Today David Chase's Commercial Plaza and I-84 occupy this section of town. (Aetna)

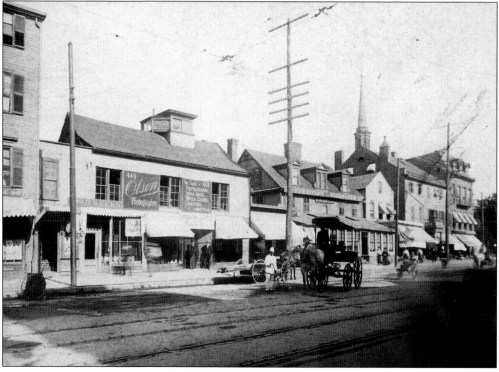

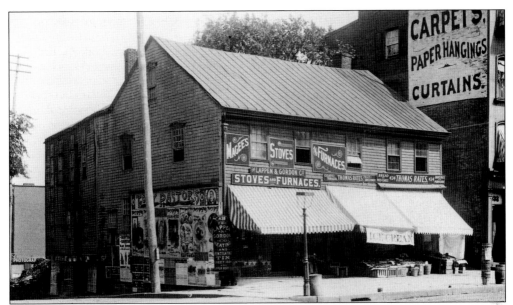

This photograph was taken at the corner of Main and Talcott Streets in the summer of 1893. It shows the oldest building in Hartford, a house built for the Talcott family in the eighteenth century. The building has been used for may purposes over the years, including a period as retail space for Lappen's and others. (Aetna)

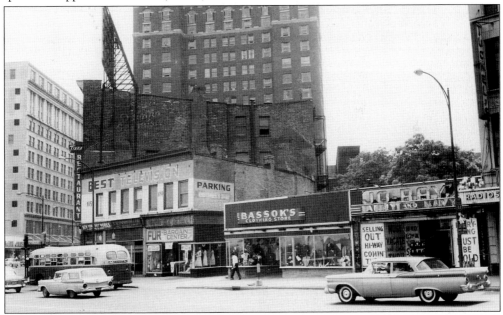

Upper Main Street looking back toward G. Fox's as the businesses prepare to depart—or as one sign puts it "Selling Out, Hi-Way Coming Thru"—so the building can be demolished to make way for I-84. Before almost every family had a car, and before the development of suburban malls drew retail business out of the downtown area, Hartford had grand department stores and lots of small businesses that could provide almost anything one could desire. The Tiara Restaurant, Bassok's Clothing, and Jo-Ray's Army Navy are familiar to long time city-dwellers. (Hartford Public Library)

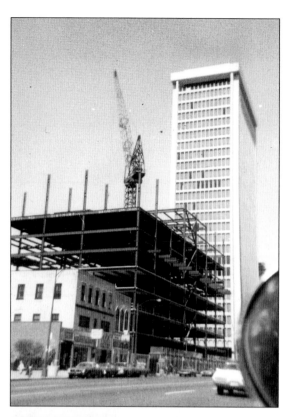

In the 1970s developer David Chase purchased land at the corner of Main and Pearl Streets and built the first modern office building in the city. Clad with reflectant gold glass, the "Gold Building" was a shock to Yankee sensibilities. This photograph was taken on March 24, 1973. (DeBonee)

The west side of Main and Pearl Street, where the Gold Building now stands, used to be home to a variety of small offices and retailers. The alley between the Drug Company and Avery's is of note because it is actually an ancient right-of-way that is marked on maps made as early as 1785. (Hartford Public Library)

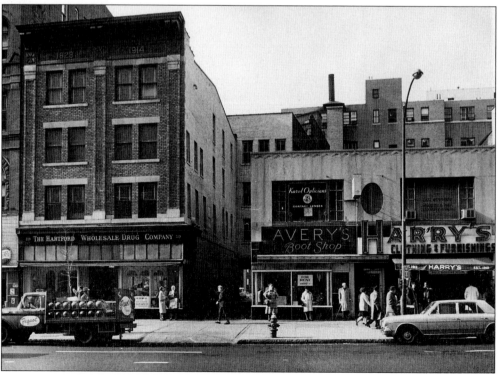

Two

Main Street to the South

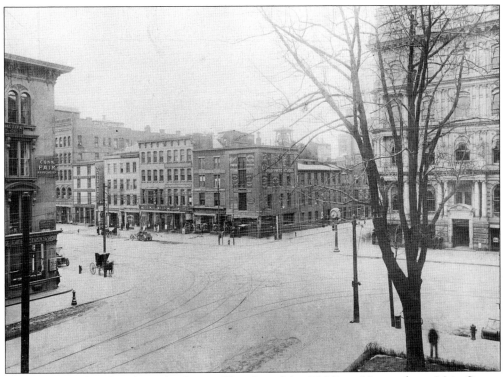

This photograph, taken from the Senate Chamber of the Old State House, shows Main Street, Central Row (at the lower left of the photograph), and Pearl Street. The 1870 Connecticut Mutual Life Insurance Company (which later became the Hartford National Bank) is on the corner with its wonderful four-sided bank clock. The combination of horses, electric trolleys, and cars help us date this image to the early 1900s. (Hartford Public Library)

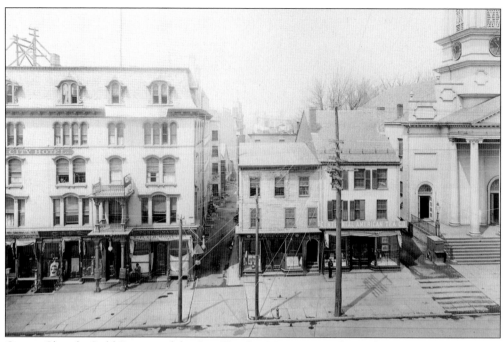

Center Church, Gold Street, and the City Hotel in May 1897. Eighteenth-century structures hug the church and hide the dens of temptation that were to be found down the alleys. (Aetna)

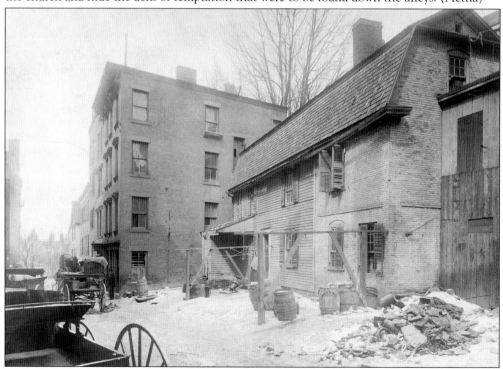

Testimony to a fast-decaying downtown: these eighteenth-century homes, barns, and tenement buildings were allowed to fall into disrepair until local philanthropist Emily Holcombe led a drive to improve the area at the turn of the century. (Hartford Public Library)

Emily Holcombe began the drive to eliminate the dilapidated structures of Gold Street and to restore the Ancient Burying Ground to a proper and respectful situation in 1900. This photograph shows the area once the beautification was completed. (Aetna)

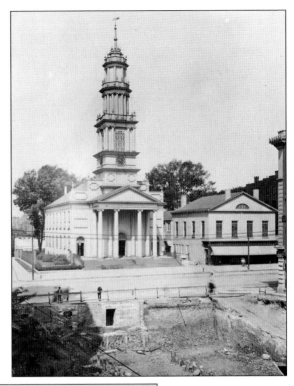

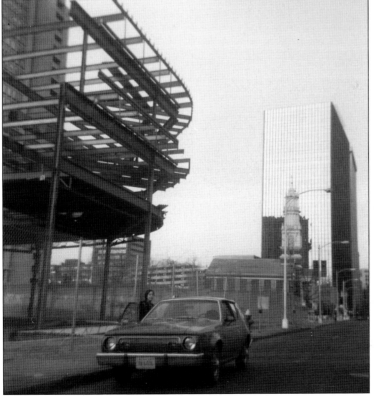

The Urban Renewal movement hit Hartford in earnest in the mid-1970s. From Center Church south to Wells Street all shops, apartments, theaters—and even entire streets—were swept away. This view, taken on December 25, 1976, shows the MDC's new headquarters under construction. (DeBonee)

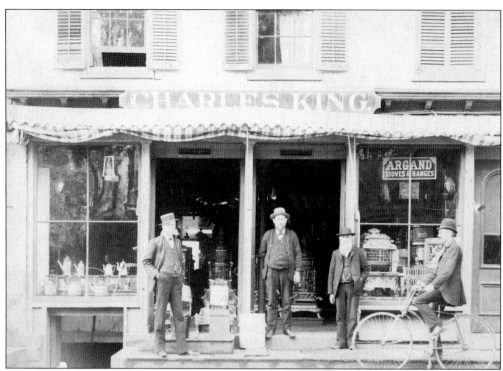

The Charles King Store was located at 497 Main Street in the 1880s. It featured everything a nineteenth-century customer could want for the home and hearth. (Hartford Public Library)

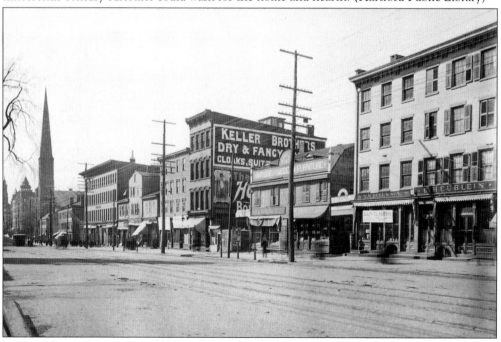

Looking down the west side of Main Street from Mulberry Street. Mulberry Street used to be directly across from the Wadsworth Atheneum, but it was absorbed in the 1970s development of Bushnell Plaza. The tall spire is that of the Baptist Church. (Aetna)

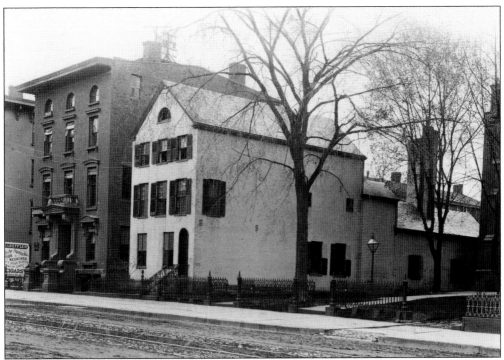

The old Clark House in April 1893. This historic home was located on the east side of Main Street between Central Row and Grove Street. It was torn down in 1906 to make way for The Travelers Tower. (Aetna)

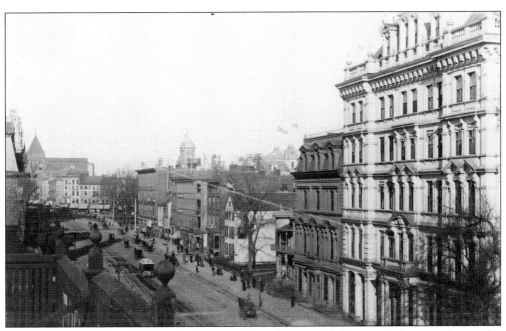

Main Street from Central Row (at the top of the photograph) down to Atheneum Square (in the bottom right corner) as seen in 1889. (Aetna)

The building of the great home office of The Travelers Insurance Company was a conservative, step-by-step, pay-as-you-go process that took take over twelve years—from 1906 to 1918. The spectacular structure was designed by Donn Barber of New York. This photograph shows the first half of the side of the building that faced Main Street. The second half, right of the door, would later be added so the door sat in the center. (Old State House)

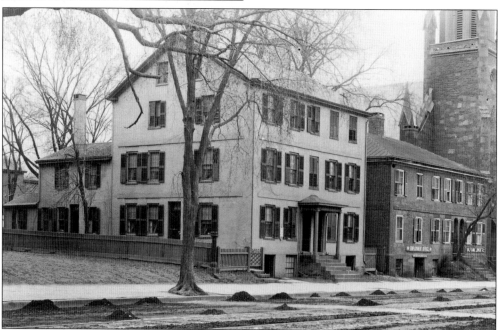

The old Brainard House in April 1893. This historic home used to stand on Main Street, on the spot where the Wadsworth Atheneum's Colt and Morgan Memorials stand today. The spires to the right belong to St. John's Episcopal Church, which was originally located here before it was moved to West Hartford. (Aetna)

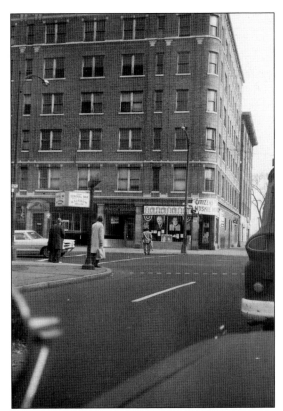

The Park Central Hotel at the corner of Main Street and Charter Oak Avenue on November 4, 1968, when the presidential campaign headquarters of Humphrey/Muskie occupied the corner. The building was razed in March 1969. (DeBonee)

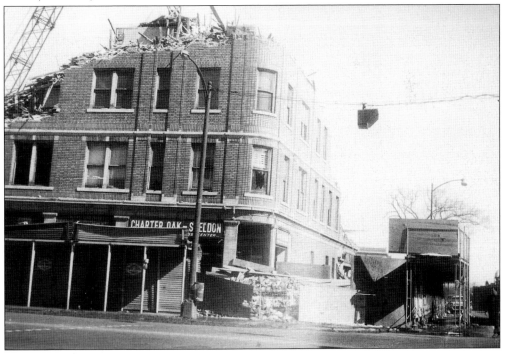

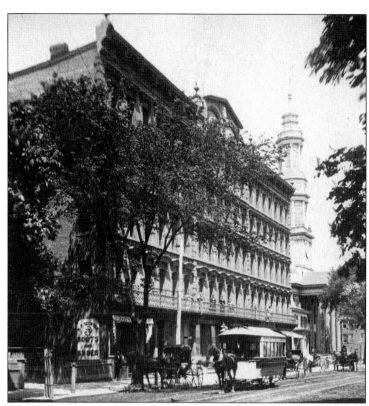

This block, containing Citizens Grocery and a nineteenth-century apartment building, stood just south of South Congregational Church. (Old State House)

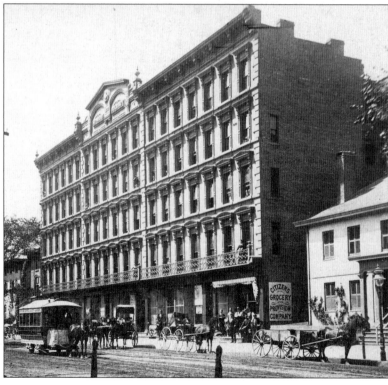

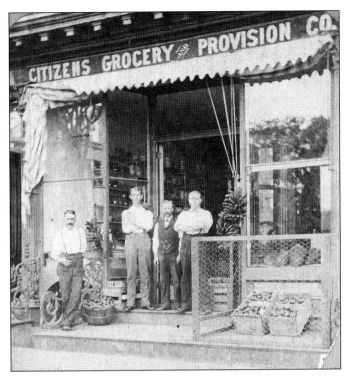

Citizens Grocery, also known as the John A. Conklin Store, was a prime example of the small retail outlets that are needed to make a city liveable. Unfortunately, this block was razed on April 22, 1958, another victim of the Urban Renewal mentality that was responsible for the loss of so many of Hartford's landmarks. (Old State House, Hartford Public Library)

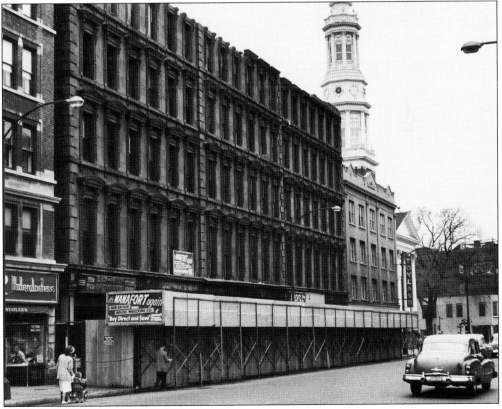

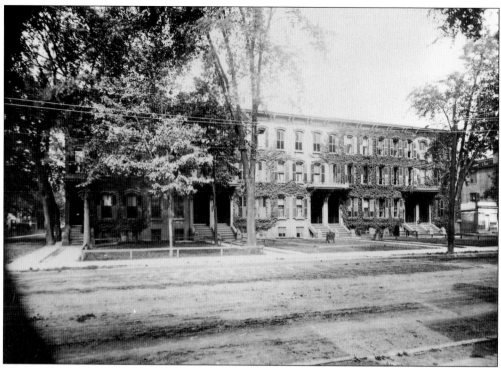

These fashionable townhouses were built on Buckingham Street at the corner of Main in 1864. This photograph was taken in 1891. (Aetna)

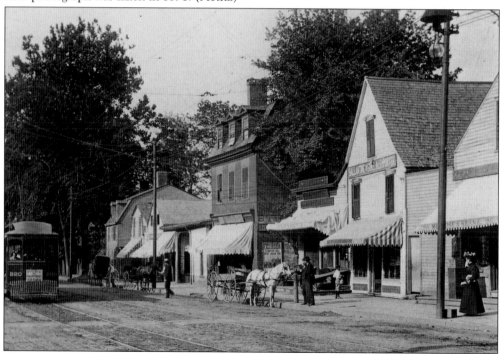

A view looking north from Main Street and Charter Oak Avenue taken on July 18, 1896. (Aetna)

Three

Neighborhoods to the South

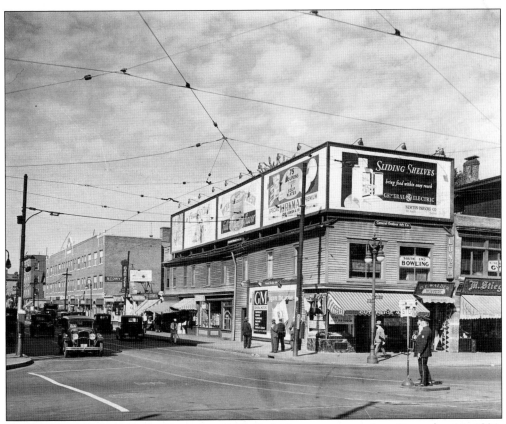

The corner of Park and Main Streets, c. 1932. Park Street was named on December 14, 1821, after Barnard Park, which in turn was named after Hartfordian Henry Barnard. Barnard, an extraordinary man who became the first United States Commissioner of Education in 1867, was born in a house that still stands at 118 Main Street. Barnard Park, now known as South Green, was the first park in Hartford. (Hartford Public Library)

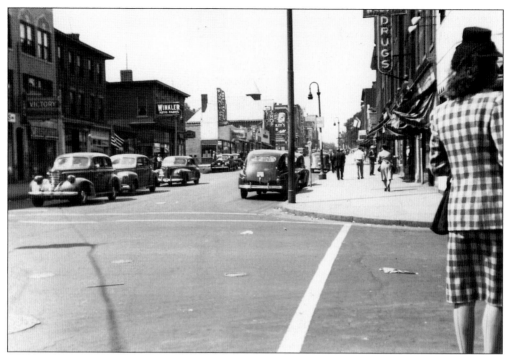

A view of Park Street looking west from Broad Street, as seen on August 29, 1943. Winkler Auto Parts on Park is a useful point of reference for making out landmarks in the photograph below. (DeBonee)

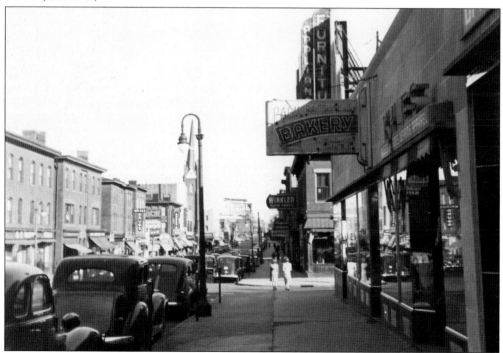

Looking down Park Street on October 29, 1944. Stores, small businesses, and apartments were all to be found on Park Street in the 1940s. (DeBonee)

Looking west to Pope Park from Park Street in June 1945. (DeBonee)

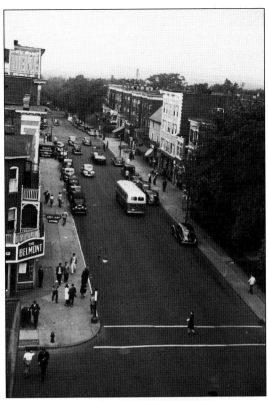

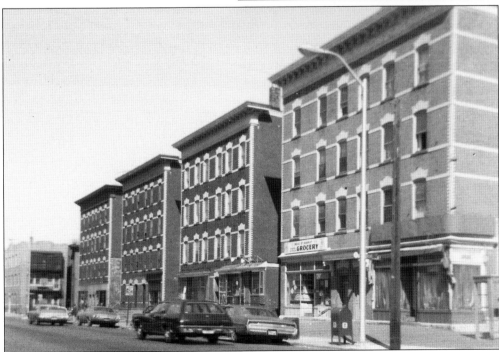

These "famous four" apartment buildings stood at the corner of Broad and Ward Streets. (DeBonee)

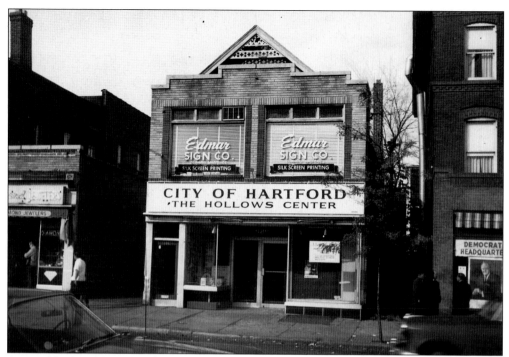

As neighborhoods change and the original residents move out, once-elegant houses are often adapted for commercial use. This photograph typifies such change: behind the 1950s facade of the Hollows Center and the Edmar Sign Co. one can see the Victorian gingerbread peak of the original building. (DeBonee)

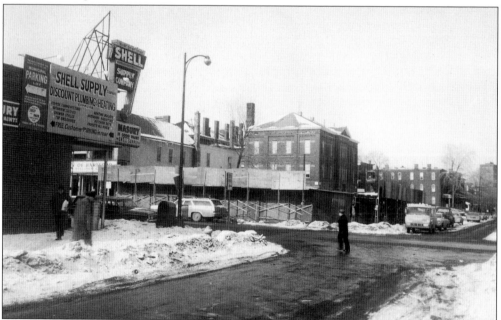

The Lawrence Street School at the corner of Park and Lawrence Streets. The Democratic Campaign Office shown in the photograph above had been razed by the time this photograph was taken. (DeBonee)

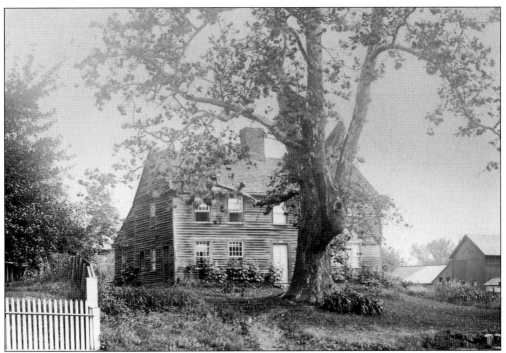

What happened to all of the seventeenth and eighteenth-century homes that once graced Hartford? This photograph, taken on July 6, 1894, shows one of the old homes on Retreat Avenue. (Aetna)

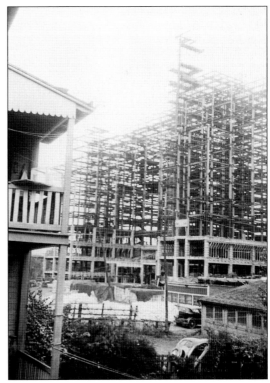

In order to meet the needs of a growing city, entire neighborhoods were wiped out when the huge Hartford Hospital was built. This view of the construction was taken in May 1946. (DeBonee)

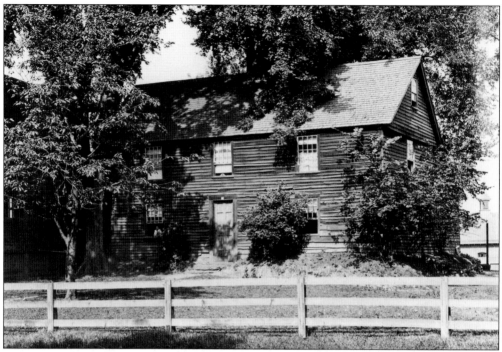

This venerable seventeenth-century home on Lafayette Street had weathered over two hundred Hartford winters by the time this photograph was taken on August 6, 1894. (Aetna)

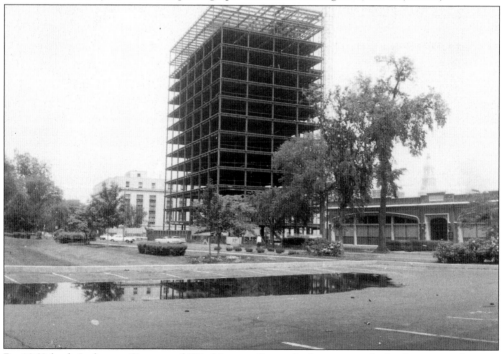

By 1968 both Lafayette Street and Washington Street had more car dealerships, courthouses, and offices of state government than elegant old homes. This photograph shows 60 Washington Street under construction.

Four

Civic Center Neighborhood

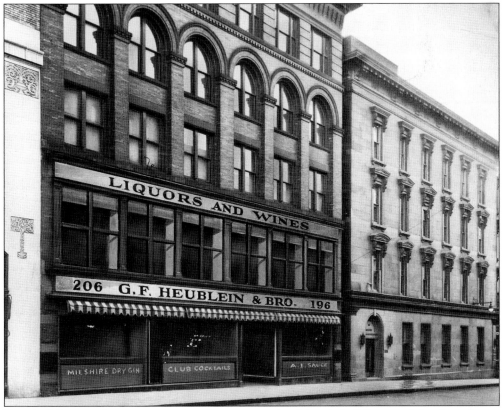

Trumbull Street is fortunate enough to have retained its historic buildings, and the three shown here on the east side of the street are all still in excellent condition. On the far right is the 1861 Charter Oak Bank Building on the corner of Asylum Street, which is occupied today by Charles Schwab. Next to it (to the left) is the 1896 Heublein Building, which has now been restored to this unpainted appearance and houses a variety of businesses. On the far left is the 1926–28 Steiger Building, which now houses Zu-Zu's Cafe, Congress Rotisserie, and the Professional Barber Shop. (Hartford Public Library)

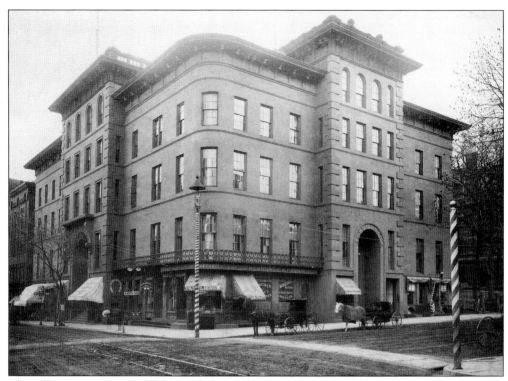

The Allyn House Hotel, a fashionable hotel that hosted visitors as important as Lincoln, once stood at the corner of Trumbull and Asylum Streets. (Hartford Public Library)

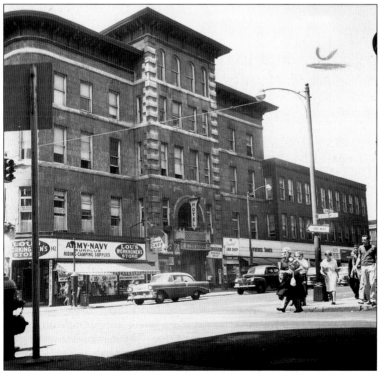

By the 1950s the Allyn House Hotel had definitely seen better days. Its reputation was less than desirable, and the cheapest of commercial rehabilitation had greatly altered its facade. (Hartford Public Library)

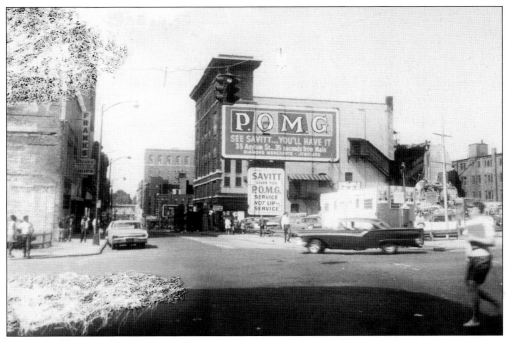

By the time this photograph was taken, the Allyn House Hotel had been razed to make way for a parking lot. Bill Savitt decorated the facade with his famous P.O.M.G. slogan. Frank's Restaurant was in the Resolute Building on the left, which is now City Place. (DeBonee)

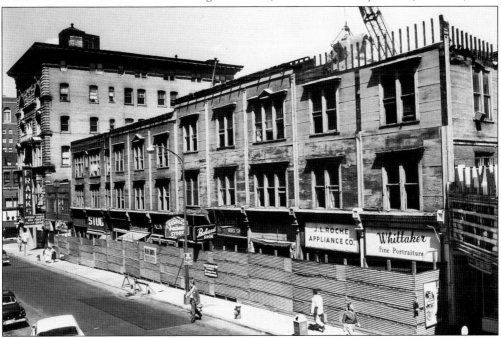

The Allyn Theater and this full-service block stood on Asylum Street just before Ann Street. The retail block was home to the famous Frank's Restaurant. Opened by Frank Lenti and Frank Parseliti on August 1, 1944, the popular restaurant moved twice and eventually retired with the immortal Frank Parseliti Sr. on May 13, 1995. (Hartford Public Library)

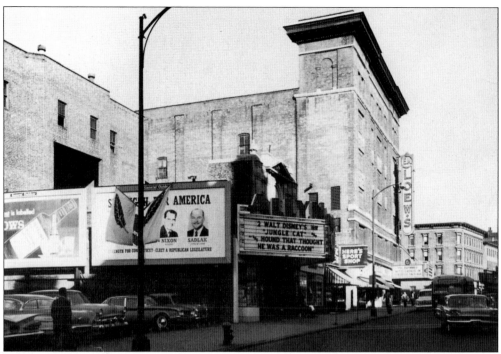

A view of Asylum Street looking east toward the Allyn Theater, E.M. Loew's, and Trumbull Street. Herb's Sport Shop is still in business, but is now located on Main Street. (Hartford Public Library)

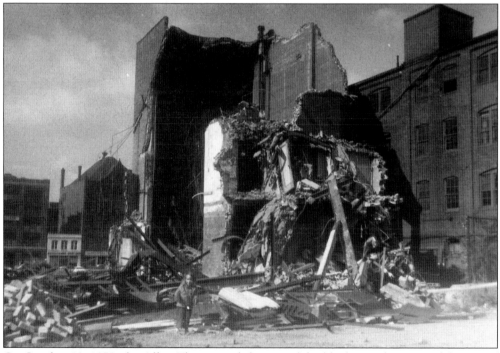

On October 18, 1970, the Allyn Theater and the rest of the block were being razed for one of the few achievements of Urban Renewal—the Hartford Civic Center. (DeBonee)

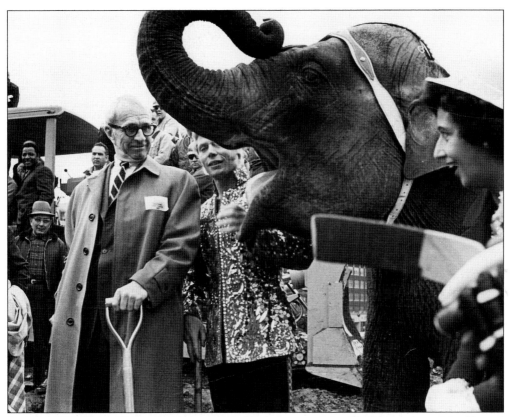

In April 1971 Olcott D. Smith, chairman of the Aetna, was joined by Mayor Anne Uccello and a circus elephant to break the ground for the new Civic Center. Designed by Vincent G. King of Philadelphia, it opened in 1975. (Aetna)

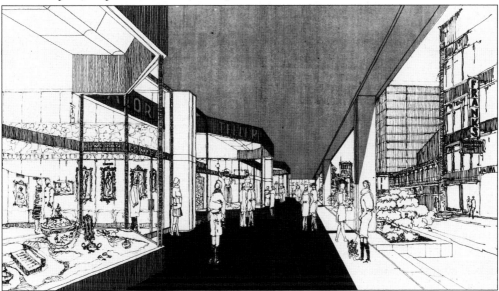

The original plan for the Civic Center included a series of street arcades that would encourage people to stroll, window shop, and enjoy the city. (Aetna)

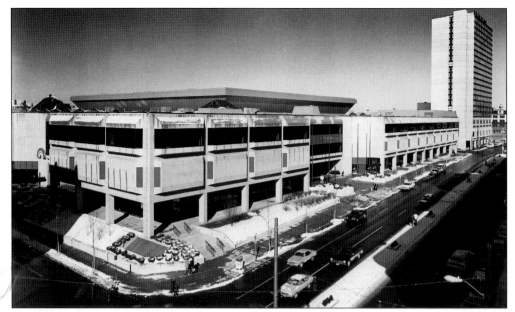

The Civic Center as it looked on February 10, 1975, just a month after the great opening on January 9, 1975. Today the open arcades have been enclosed, and the central stairs leading the public in have been eliminated. To many it is now a curious mess of concrete that has no real entrance. (Aetna)

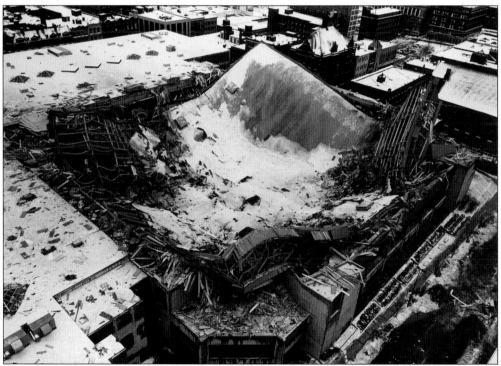

There was a basketball game, a full arena, a winter's snow, some rain, and freezing temperatures. Incredibly, quietly, on the morning of January 7, 1978, the Civic Center roof collapsed. Remarkably, no one was killed. Hours made the difference. (Aetna)

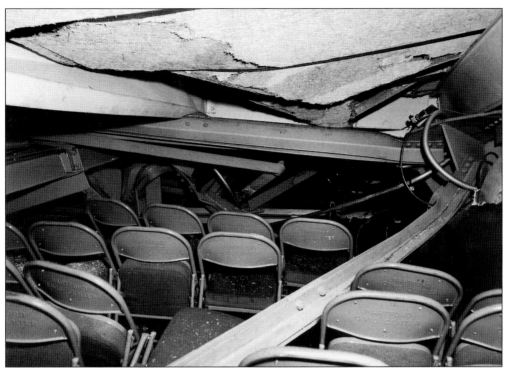

This view, looking east-southeast from the rink level, was taken by Zaremba of Bloomfield for the Aetna on January 18, 1978. (Aetna)

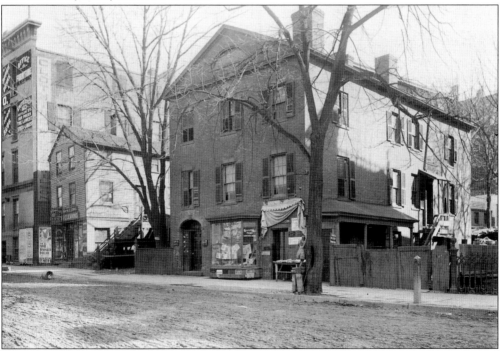

An 1897 photograph of the old Corning family house on Trumbull Street between Pearl and Asylum Streets. (Aetna)

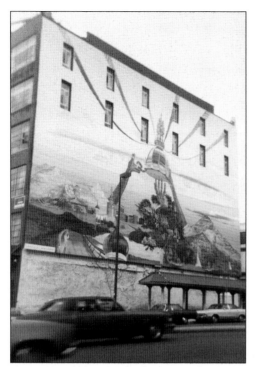

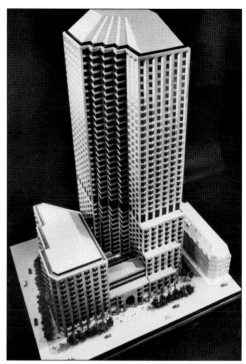

For nine months, Hartford artist Michael Borders worked to create the *Genesis of the Capital City*. Commissioned by the Knox Foundation and the Downtown Council under Stanley Schultz, the great mural (it was 68 feet tall and 110 feet wide) filled the Trumbull Street side of the Resolute Building. The mural was completed in November 1973 but was lost in the spring of 1978 when the Resolute Building was razed to make way for City Place. Elegant, masterful, and memorable, its loss was made all the more painful by the bland, forgettable, faceless appearance of City Place. Lacking humanity, style, and even entrances, City Place is one of the few buildings which turned out to be as bad as the architectural model, only taller. (DeBonee, Aetna)

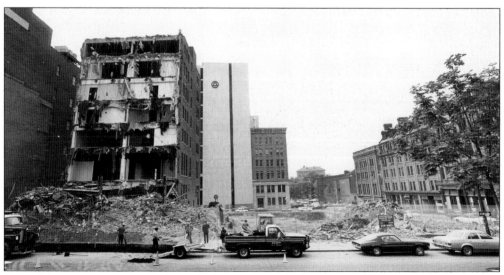

Demolition of the Resolute Building in full swing on Asylum Street. (Hartford Public Library)

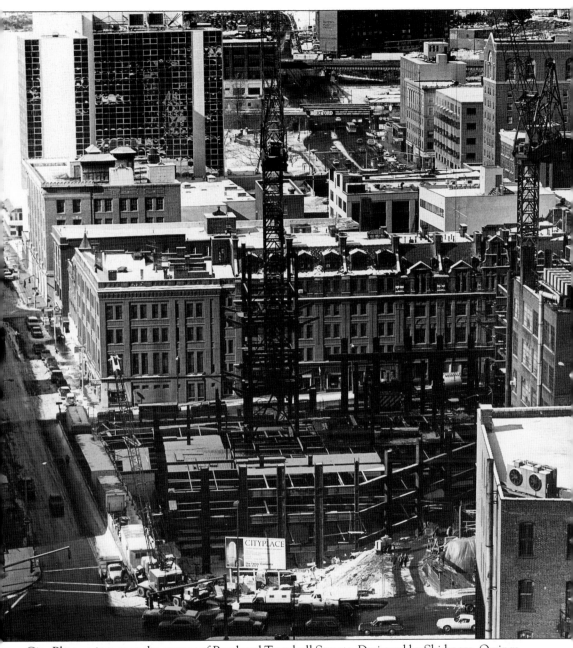

City Place going up at the corner of Pearl and Trumbull Streets. Designed by Skidmore, Owings, and Merrill, the 39-story, 535-foot building was completed in 1983. The Goodwin on Haynes Street can be seen behind it, then the Light Company on Ann, and the Hilton Hotel on the Park. (Aetna)

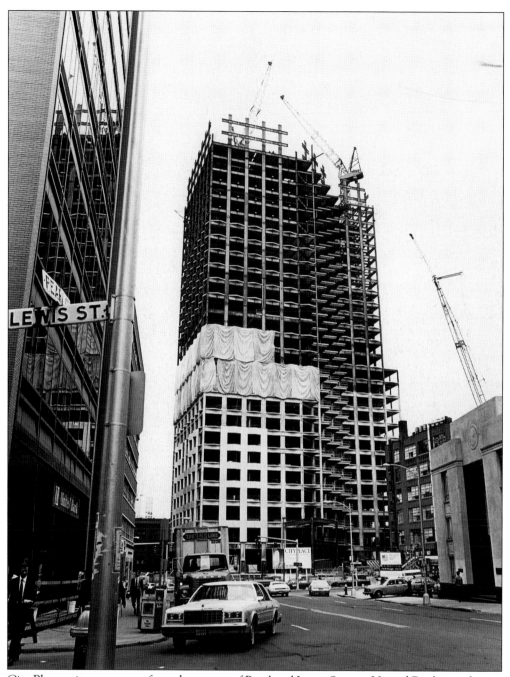

City Place going up as seen from the corner of Pearl and Lewis Streets. United Bank is no longer in business (it was lost to mergers), and what used to be its home office is now a police museum and substation. (Aetna)

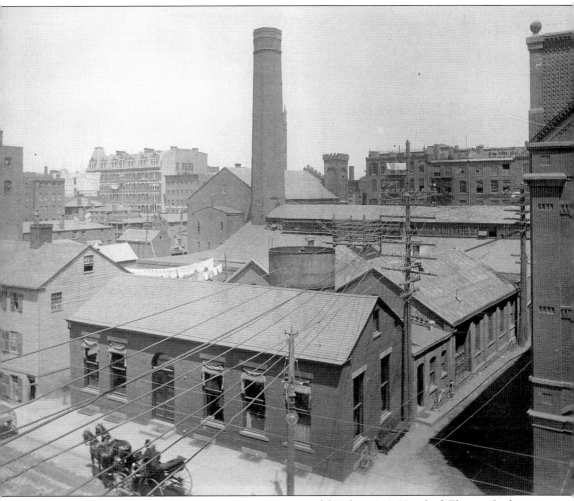

Today the corner of Pearl and Ann Streets is occupied by the 1913 Hartford Electric Light Building. This photograph shows the same corner in the 1880s, when electricity was literally "made" at this spot. To the far left, at the corner of Asylum and High Streets, is the Garde Hotel. Next door the eighteenth-century house seems lost amidst the new commercial activity and wires. (Hartford Public Library)

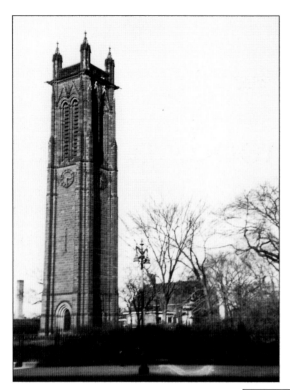

The most prominent landmark north of downtown is the Keney Memorial Clock Tower. The clock was given to the city by Henry Keney in memory of his mother, as a tribute to her "wisdom." Designed by Charles C. Haight in 1898, it is modeled on the Tour Jacques in Paris. The clock has been recently restored by the city. (DeBonee)

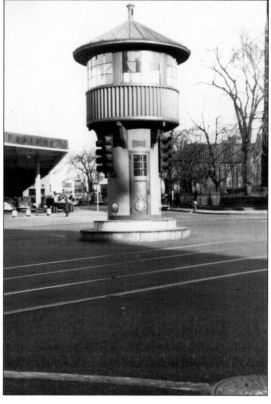

Beside the Keney Tower, at the busy intersection of Main and Albany Streets, stood this efficient traffic island. However hectic the roads were, from this simple island the traffic lights could be monitored and the traffic kept moving. The island worked so well a city traffic engineer had it removed. (DeBonee)

Five

Neighborhoods to the North

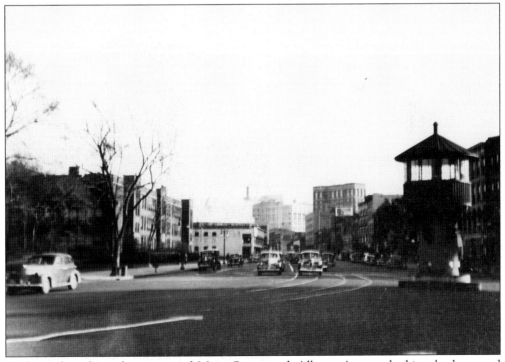

A shot taken from the corner of Main Street and Albany Avenue looking back toward the downtown. This view was taken on December 5, 1942, before highways isolated this neighborhood from the city. (DeBonee)

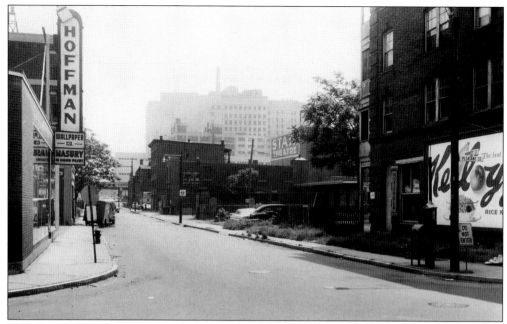

The corner of Market Street and Pleasant Street, north of the downtown. Market Street has since been displaced: all of its buildings have been removed and the people who lived and worked here have gone elsewhere. (Hartford Public Library)

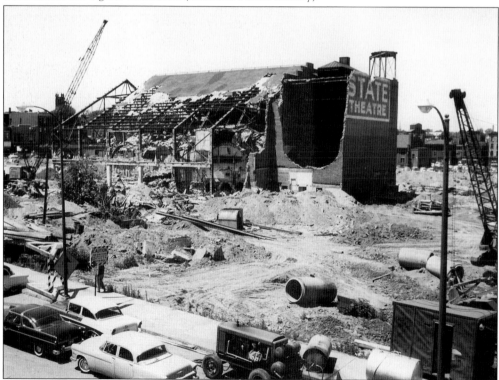

The demolition of Market Street and the State Theater to make way for Urban Renewal. (Hartford Public Library)

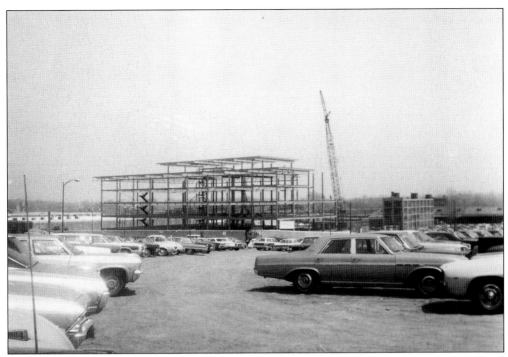

The steel frame for RPI's Hartford Graduate Center being erected on Windsor Street on April 28, 1978. (DeBonee)

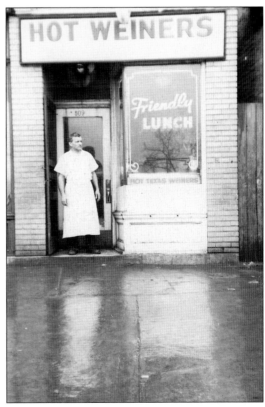

Hartford was once a city of merchants and restaurants. This view, taken on January 23, 1944, shows the Friendly Lunch at 509 Albany Avenue. Its speciality was "Hot Texas Weiners." (DeBonee)

The corner of Garden Street and Albany Avenue as seen in June 1968. (DeBonee)

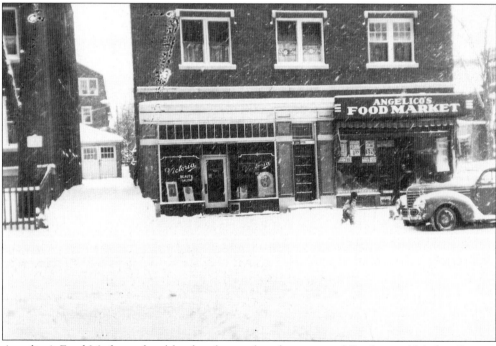

Angelico's Food Market, a local landmark, stood at the corner of Garden and Mather Streets. The store looks like a beacon of friendliness in the midst of this February 1944 snowstorm. (DeBonee)

When Hartfordians worked and lived in the city rather than going home to the suburbs, the various neighborhoods were comprised of apartments and family houses as well as stores and businesses. This photograph shows the corner of Pliny and Garden Streets on February 12, 1944. Monday was always wash day, and even the snow could not change the routine. (DeBonee)

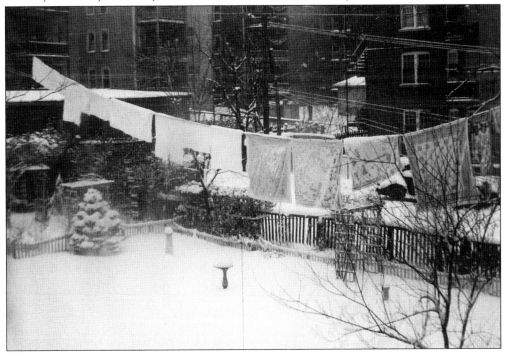

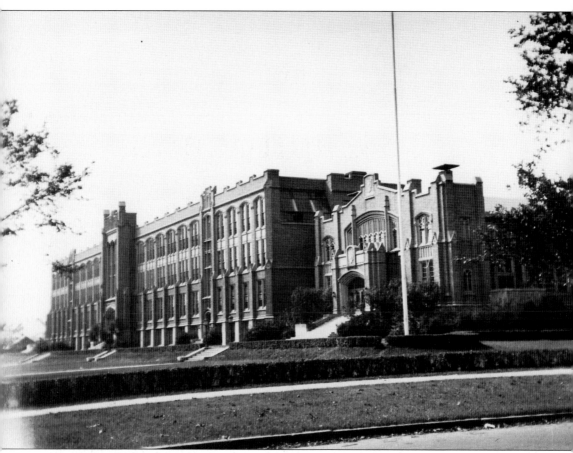

In 1922 Hartford expanded its school system with the completion of the Weaver High School. Designed by Frank Irving Cooper and Philip A. Mason, it is a wonderful structure on a great site overlooking Keney Park. Its entrance incorporates stone sculptures representing thirteen of Aesop's Fables by Anthony Zottoli of Boston. The school was named for Thomas Weaver, who was then superintendent of Hartford's schools, and all in all it was a monument to educational excellence.

Today the school is called the Martin Luther King, Jr. Elementary School. Unfortunately much of its great detailing has been boarded up, but hopefully it will someday be restored to its former grace and style. (DeBonee)

Six

The Capitol and Bushnell Park

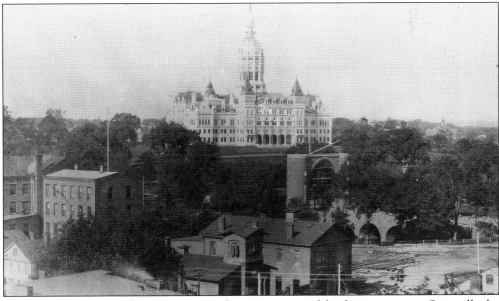

Bushnell Park consists of 36 open acres in the western part of the downtown area. Originally the Park or Meandering Swine or Hog River ran through here, and various factories and tenements filled parts of the site. At the urging of Reverend Horace Bushnell, the city voted to clear the site of the tenements and create the park in 1853. First called City Park, it was renamed Bushnell Park in the minister's honor on February 14, 1876.

In 1872 the citizens of Connecticut voted to have a single capital in Hartford, replacing the dual capitals of Hartford and New Haven. Richard Mitchell Upjohn designed the great golden dome edifice and the state moved in 1878.

In 1885, under the design of George Keller, Hartford erected the first memorial arch in America, its Soldiers and Sailors Memorial Arch, as a monument to the Civil War. The arch is shown here under construction, its twin towers rising slowly. Today it still stands, fully restored thanks to the care of the Bushnell Park Foundation. (Hartford Public Library)

In the middle of the park, beneath the capitol's north lawn, was a great terrace that held public bathhouses and served as a concert platform. (Hartford Public Library)

An aerial view of the park showing the 1899 Corning Fountain in the foreground and the capitol and the State Armory in the upper right. Designed by Benjamin Wistar Morris in 1909, the armory has recently been restored. The river in the foreground has, unfortunately, been placed in a pipe—out of sight. (Hartford Public Library)

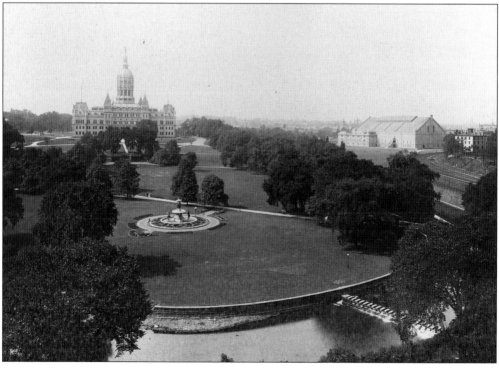

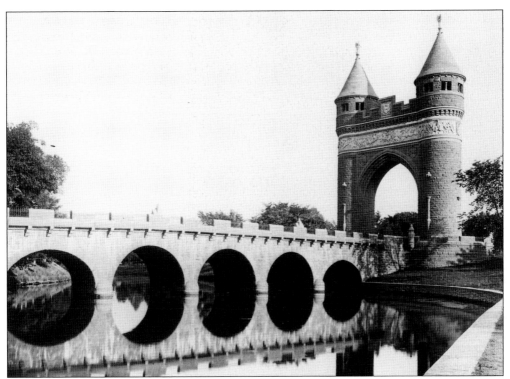

This wonderful photograph of the Soldiers and Sailors Memorial Arch and the accompanying bridge across the river was taken in 1889. (Aetna)

Just west of the park is Flower Street, named after Ebenezer Flower, who was mayor of Hartford from 1851 to 1853. The wooden bridge that originally stood here was replaced in 1885 by this brick arch bridge at a cost of $19,557.24. (Hartford Public Library)

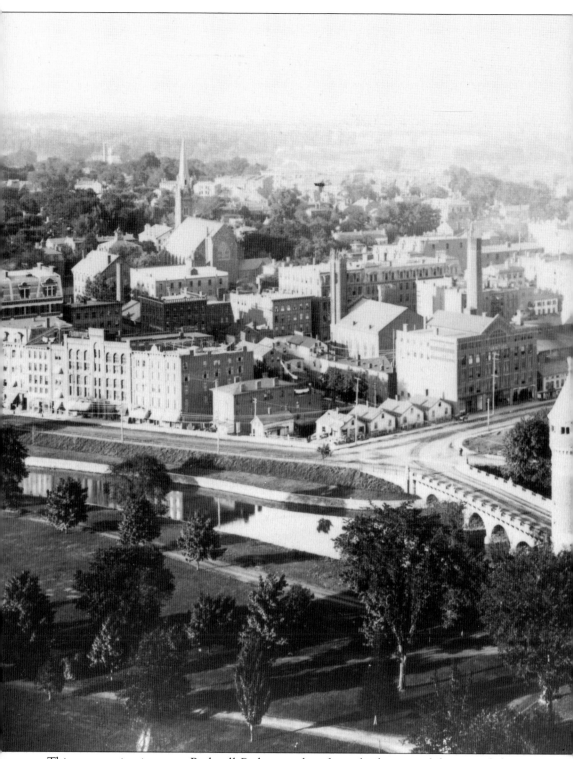

This panoramic view over Bushnell Park was taken from the lantern of the capitol dome in

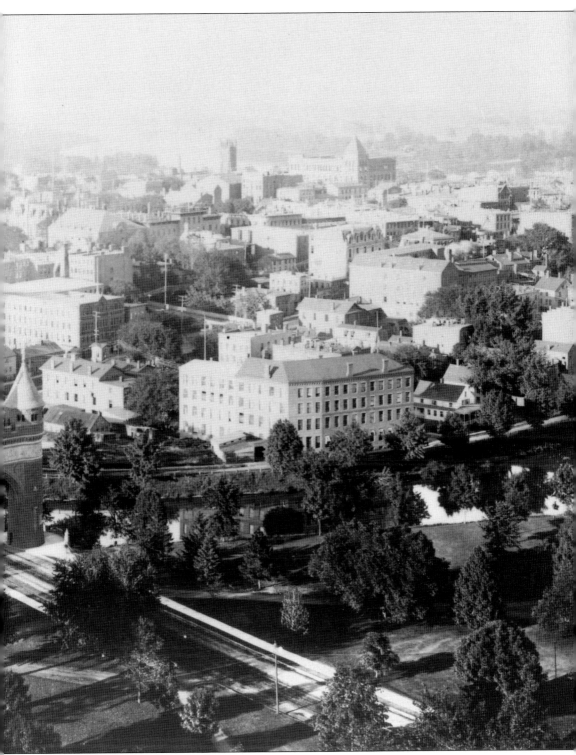

1888. It shows the view looking northeast towards the downtown. (Aetna)

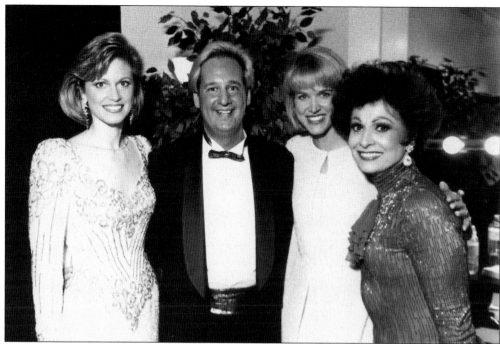

On June 12, 1994, a new tradition was created in Hartford by The Bushnell Memorial under the inspired tutelage of Doug Evans and Ronna Reynolds. To celebrate the New York Tony Awards, the Bushnell held its own awards ceremony—and the result was a star performance that had the Big Apple taking notes. In this photograph Denise D'Acenzo of WFSB (Channel 3), Doug Evans, Paula Zahn of CBS, and Carol Lawrence pause backstage before the show. (Bushnell)

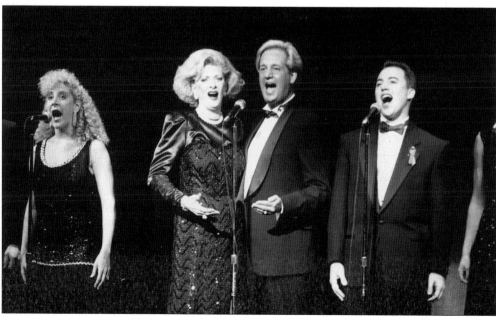

Carmen Nardone, Catherine Tremaine (the ceremony's artistic chair), with Douglas Evans and David Dalena at the Tony evening. (Bushnell)

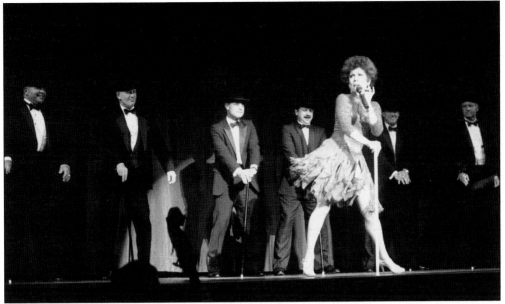

Carol Lawrence, winner of a Bushnell Tony, gave the audience a never-to-be-forgotten performance. The evening has become a must-be-at event, and it is always a sellout. (Bushnell)

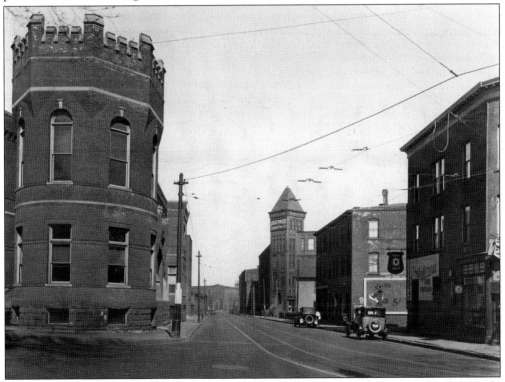

Hartford's factory district began on Capitol Avenue at Laurel and included Sharpe's Rifle Works, the Crystalab Building (on the left), and the Underwood complex (on the right). The construction of I-84 wiped out the Underwood complex, and on May 28, 1995, the Crystalab Building burned to the ground. (Hartford Public Library)

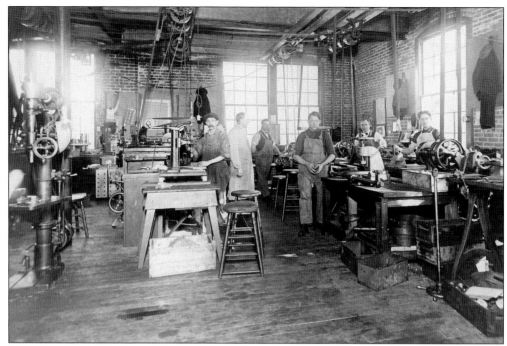

This machine shop belonged to the Capitol Motors Company, located on Capitol Avenue near Main Street. We cannot identify everyone in this photograph, but we do know that the second person on the right is Rudolph Libutzke. (Hartford Public Library)

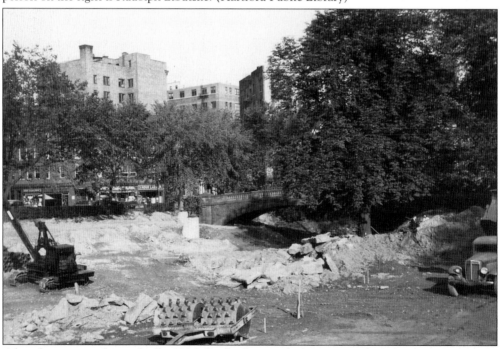

After the city was hit with the 1936 flood, plans took shape to enclose the Park River so it would not devastate the city again. This view of the filling-in process in Bushnell Park was taken on August 8, 1944. (DeBonee)

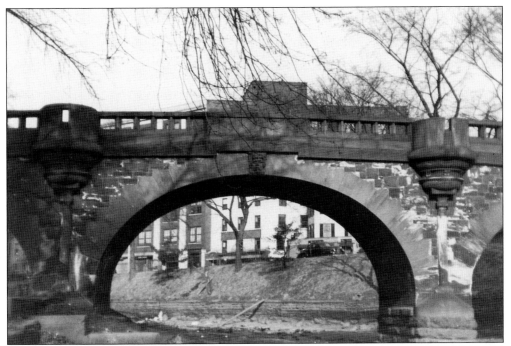

One of the bridges that crossed the Park River into Bushnell Park was the Hoadley Memorial Bridge on the eastern end of the park. As part of the river work, the bridge was demolished and only its bronze plaque remains. (DeBonee)

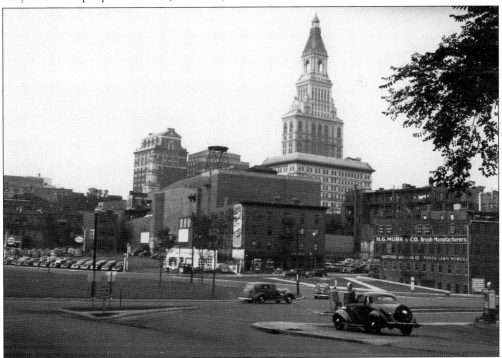

With the Park River buried, a new traffic circle emerged in 1946. Named for the great Polish general Casimir Pulaski, the circle helps move cars on to I-84 and I-91. (DeBonee)

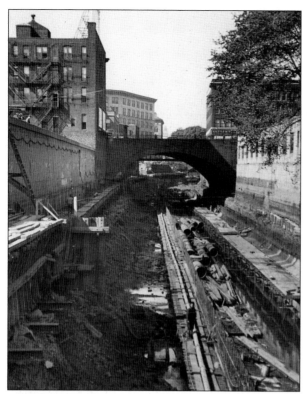

The highway placed above the now-buried Park River is known today as the Conland-Whitehead Highway. It was named for Henry H. Conland, former publisher of the *Courant* and chairman of the Bridge Commission, and Ulmont I. Whitehead Jr., who was killed on December 7, 1941, at Pearl Harbor. (DeBonee)

The Conland-Whitehead Highway between Arch and Sheldon Streets. On the left is Taylor & Fenn; on the right Allen Manufacturing. Working factories were once an integral part of the city employing thousands of city-dwellers. (Hartford Public Library)

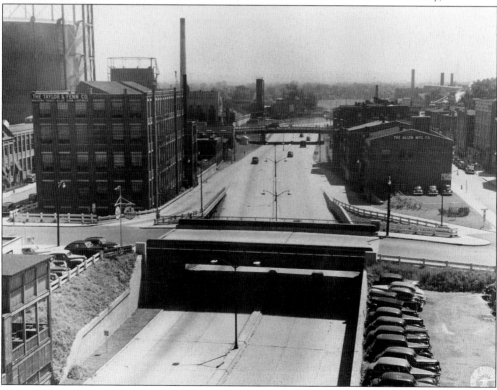

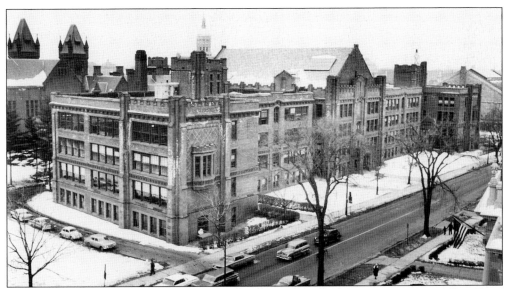

Just west of the railroad station and Bushnell Park was Hartford Public High School. The school was built in 1870, but over the years new buildings were added until the whole complex spanned an area from Hopkins Street to Broad Street. The planners that had I-84 carve up the city also came up with the ridiculous idea of placing the highway in the path of HPHS and by 1965 the highway had made a memory of these buildings. (Hartford Public Library)

With the old Hartford Public High School slated for demolition, someone decided that the place for the new high school was Nook Farm, on Forest Street, the most important literary neighborhood of nineteenth-century America. So landmark after landmark was bulldozed for an extremely unimpressive new building. It's a monument all on its own—but hardly to excellence. (Hartford Public Library)

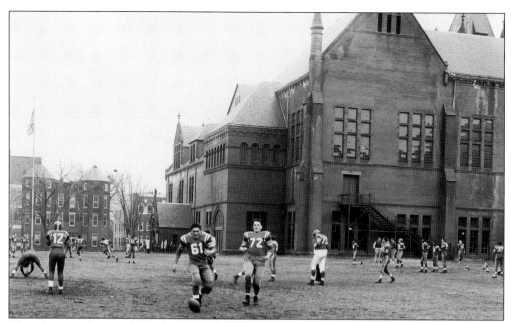

This photograph was taken when Hartford Public High School was at the corner of Hopkins, Farmington, and Broad Streets. Because the football field was below street level, it flooded very easily and became a sea of mud after a scrimmage or two. (Hartford Public Library)

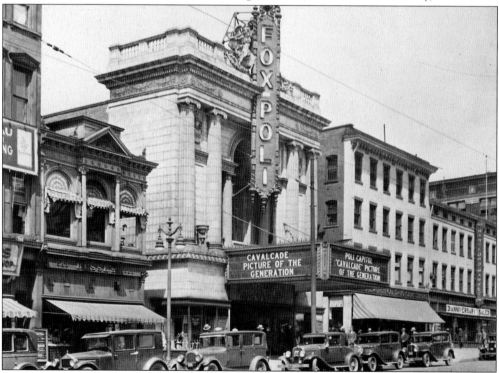

There were many great movie or moving picture houses in Hartford. Many, like Fox Poli, were converted vaudeville houses. All, unfortunately, are gone now. Fox Poli was on Main Street, between Gold and Wells Streets. (Hartford Public Library)

Seven

Leisure Time

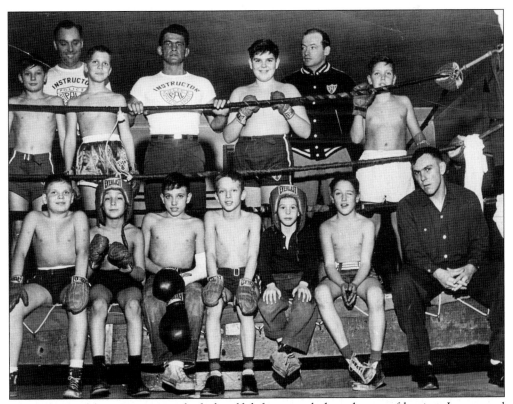

The Police Athletic League taught kids self-defense, including the art of boxing. It was, and continues to be, a solid institution where many city kids learn boxing, discipline, and a few lessons about life. Bill Kearns, the instructor shown here in the center of the top row, was himself a professional boxer of considerable note. (Kearns)

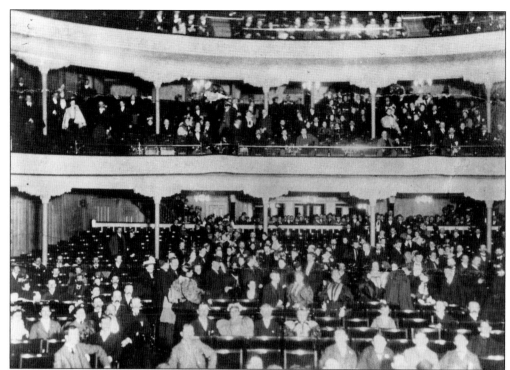

Parsons Theater, located at the corner of Prospect Street, Central Row, and American Row, used to be an important venue for theater in Hartford. This photograph was taken on April 1, 1896, the theater's opening night. The theater was later razed to make way for the new home office of The Hartford Steam Boiler Inspection and Insurance Company, and that building is now part of the Phoenix Home Life. (Hartford Public Library)

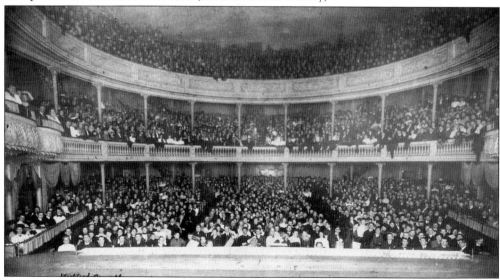

The Hartford Opera House, a cavernous affair (and undoubtedly a fire trap), was located on Main Street. This picture was taken during the February 13, 1904, matinee of *Queen of the White Slaves*. This performance was sold out and the theater was filled to capacity with an audience of 2,093. (Hartford Public Library)

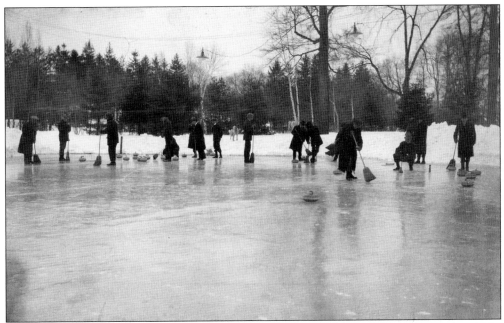

When the winters were cold and the waters froze, all kinds of recreational activities could be enjoyed in the city. These people are curling on the pond in Elizabeth Park in 1914. (Hartford Public Library)

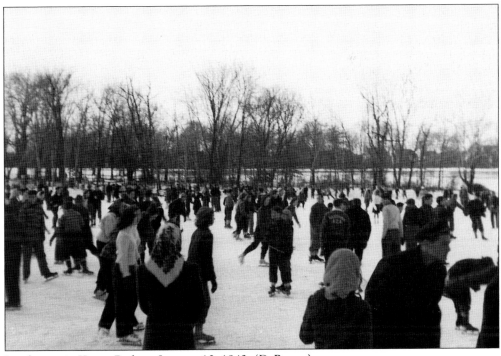

Ice skating in Keney Park on January 10, 1943. (DeBonee)

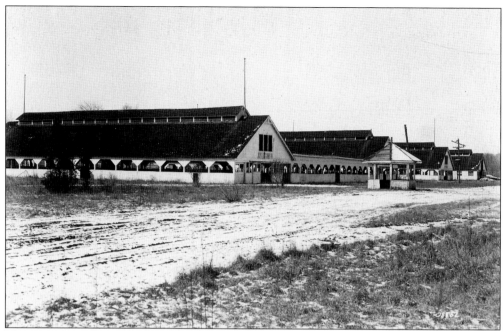

The Charter Oak Park was a great place for harness racing, as well as for fairs with exhibitions of farm products and animals. These photographs show the fairgrounds in 1937 (above) and the grandstand (below). Today the deserted Chandler Evans factory stands on this site, but it will probably soon be replaced with a new Home Depot store. (Hartford Public Library)

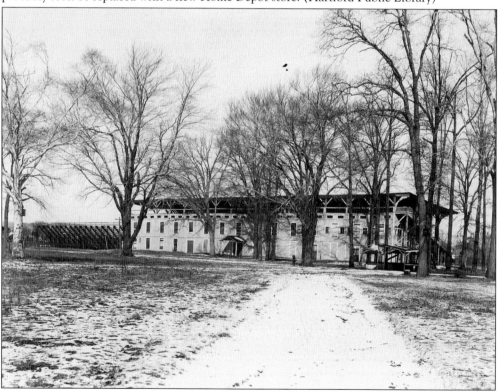

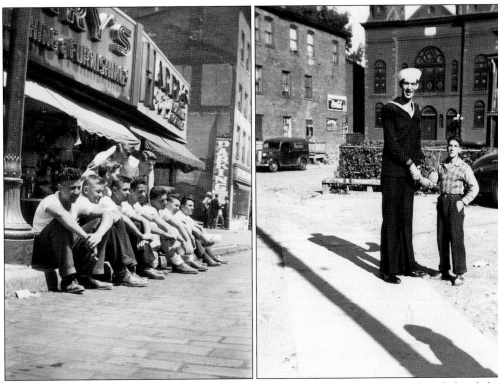

On a summer's day you could hang out on a street corner, or go to the stage door behind the State Theater to meet the personalities appearing there. (DeBonee)

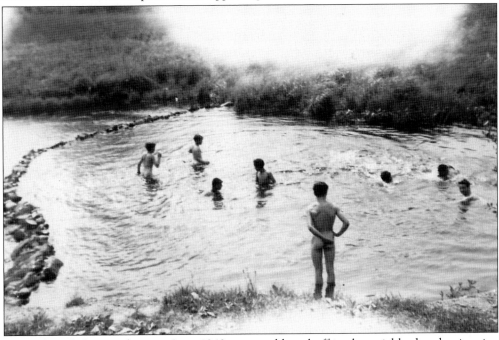

Or, as these kids were doing in June 1943, you could cool off in the neighborhood swimming hole. (DeBonee)

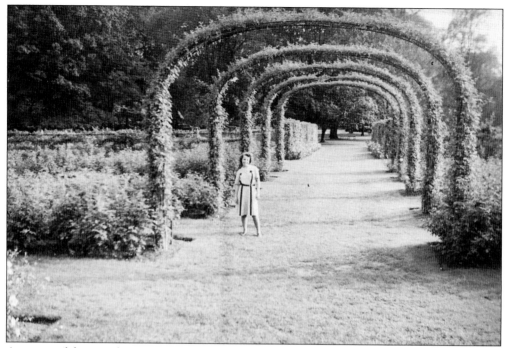

A perennial favorite for summertime strollers is the famed Rose Garden in Elizabeth Park, seen here in 1947. (DeBonee)

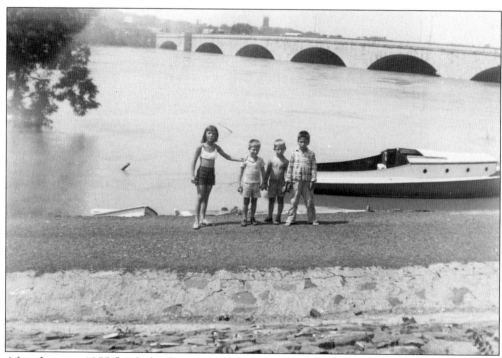

After the great 1955 flood, the Connecticut River was bank full at the Bulkeley Bridge, making it a special challenge for young swimmers. (DeBonee)

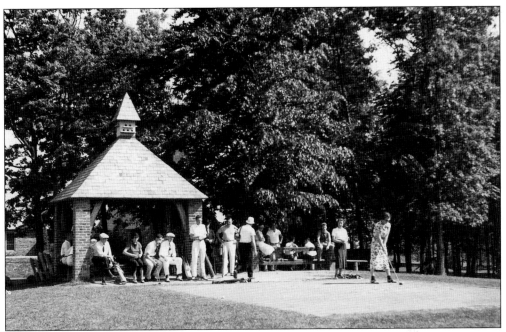

Golf tournaments were often held on Memorial Day to mark the beginning of the new season. This photograph shows players at the tenth tee during the Memorial Day Classic at Keney Park. (Hartford Public Library)

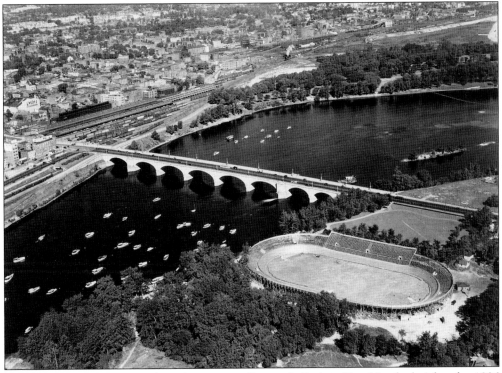

There used to be a great stadium for games at Riverside Park in East Hartford. After the 1936 flood a dike was constructed that razed the stadium. (Hartford Public Library)

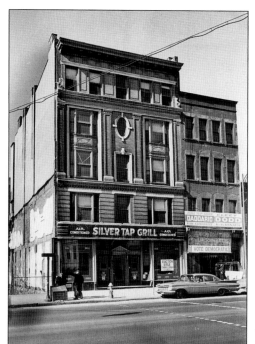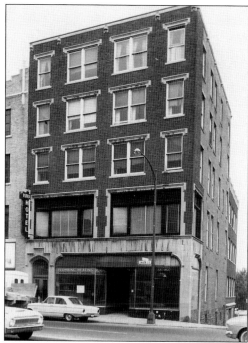

The Silver Tap Grill used to stand at 571-575 Main Street. Built around 1890, it provided food and friendly service until it was demolished to make way for the MDC Building and Bushnell Plaza. The Hotel Essex, a theatrical hotel that was built on older foundations, stood on Main Street at Trumbull. It was razed in the fall of 1963. (Hartford Public Library)

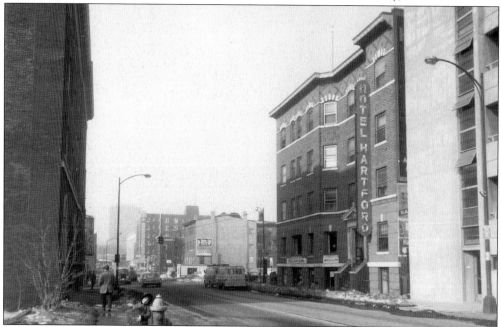

The Hotel Hartford stood next to the "City Garage" (the Hotel Sheraton's garage) at Church and Ann Streets. One day, under some ruse, some official decided that the hotel was in the way and had it condemned. (Hartford Public Library)

Eight

Places to Stay, Places to Dine

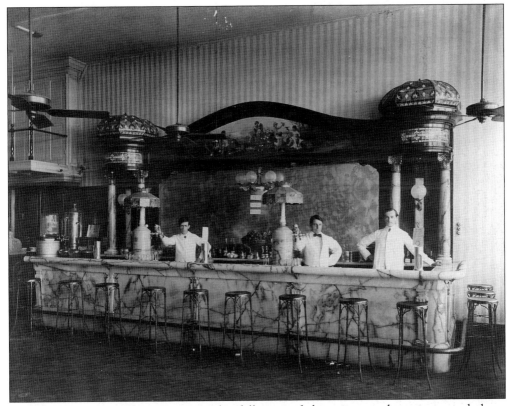

Hartford was once a full-service city with a full range of places to stay, places to eat, and places to go. Slowly, under the mantle of renewal, we have torn the heart out of the city by eradicating the small hotels and eateries. Anyone who thought such a plan would work now has to look at empty lots where people once worked, stayed, and dined.

The Soda Shop stood at 7 Asylum Street around 1915. James W. Riley and Frank W. McCune are listed as soda clerks in the city directory for that year and they are probably among the people in this picture. (Hartford Public Library)

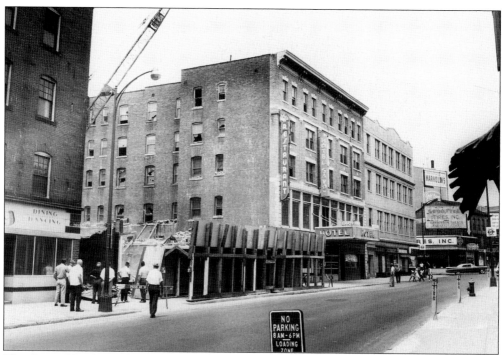

The Savoy Hotel stood at 369 Trumbull Street. It was razed when I-84 was built through the city.

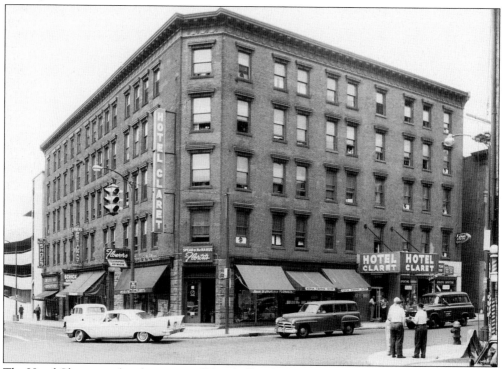

The Hotel Claret stood at the corner of Trumbull and Church Streets, where the Hotel Sheraton stands today. (Hartford Public Library)

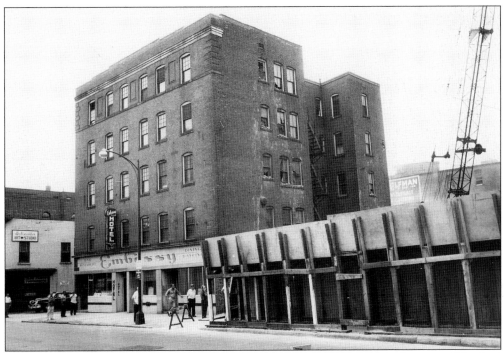

The Embassy Hotel at 347 Trumbull Street featured dining and dancing. (Hartford Public Library)

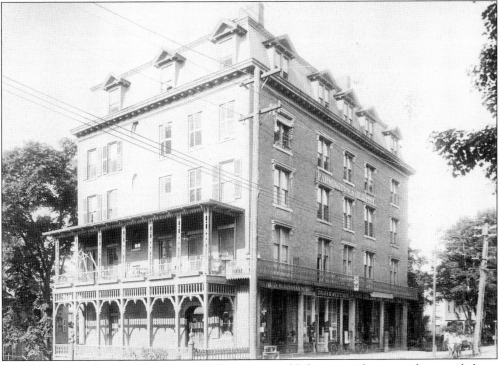

The Farmington Avenue Hotel was a full-service establishment with rooms above and shops below. (Hartford Public Library)

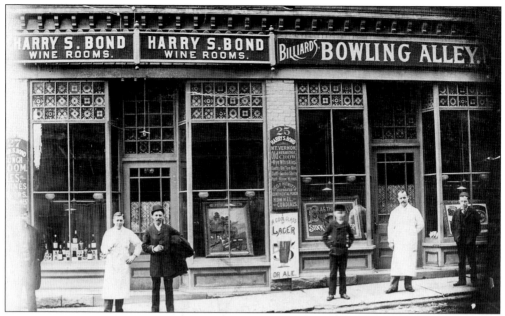

Harry S. Bond, the gentleman on the left in white, once ran wine rooms and a cafe on Temple Street. A very enterprising gentleman, Bond went on to open the Bond Hotel on Asylum Street in 1913. The building was purchased by the archdiocese in 1967 and renamed DeSales Hall. (Hartford Public Library)

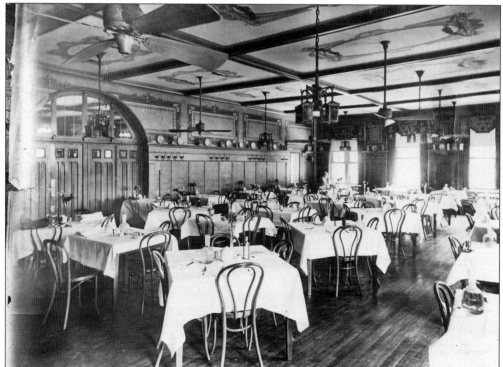

This rare photograph shows the main dining room of the Bond Hotel, where Hartford's "first permanent professional cabaret had its beginning." (Hartford Public Library)

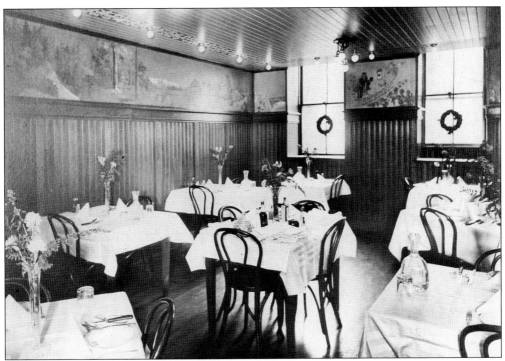

Next to the Bond was its less formal Rathskeller. (Hartford Public Library)

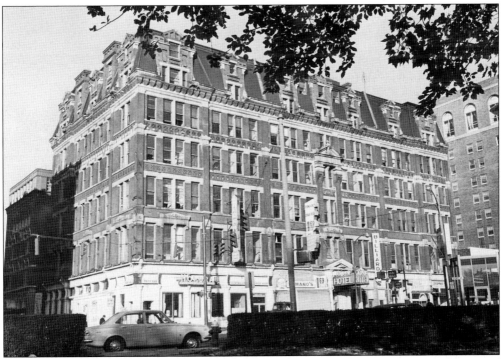

The Hotel Garde, a massive, imposing Victorian building, stood at the corner of Asylum and High Streets. It was razed in the 1970s and in 1981 Capitol Center, designed by Kane and White, was built on the site. (Hartford Public Library)

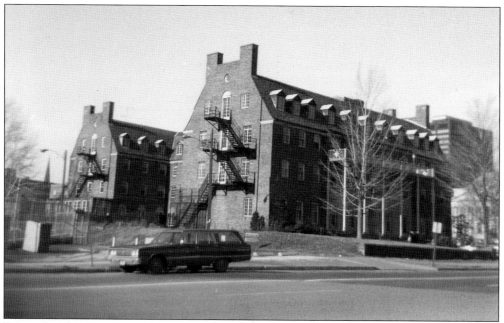

Situated near the corner of Farmington Avenue and Broad Street, the YWCA had two dormitories. The YWCA continues to have its headquarters on this corner. (DeBonee)

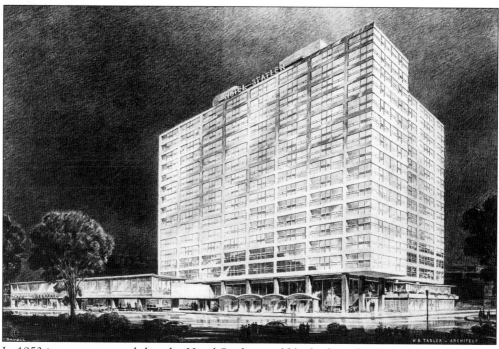

In 1953 it was announced that the Hotel Statler would be built at the intersection of Asylum, Farmington, Ford, and Pearl Streets, and with the announcement came this futuristic sketch. The hotel was opened in 1955, and it has had many names over the years, including the Statler Hilton, the Hilton Hotel, and the Hartford Hilton. On October 28, 1990, the building was imploded. (Kearnes)

Nine

The Way to Go

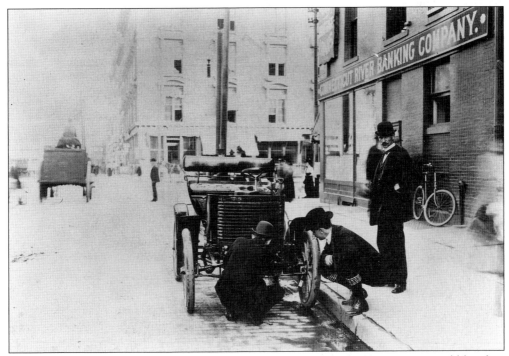

While pedaling his bicycle in 1892, Hiram Percy Maxim thought how nice it would be if an engine were connected to the bike to do the work. He called in Hayden Eames, Colonel Pope, and George Day of Pope Manufacturing and was hired as chief engineer to develop "an electric carriage." In May 1897 the Mark III was offered to the public for $3,000.

This photograph shows Mr. Maxim in 1898 with his "first car," presumably a Mark III. A breakdown? No, one suspects that Mr. Maxim is showing a curious contemporary or potential customer how it worked. Later, Mr. Maxim would form the Maxim Silencer Company using the principles he had developed for the muffler system. (Hartford Public Library)

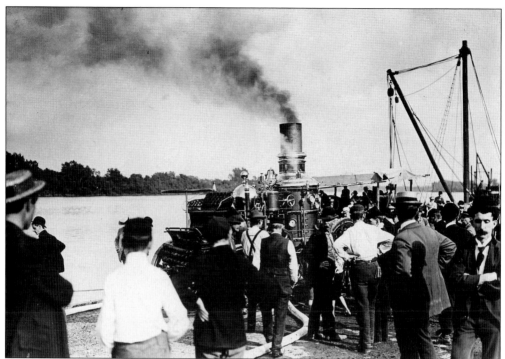

Down by the Connecticut River, the Hartford Fire Department is showing the prowess of its new steam fire engine. The gentleman on the right is not impressed. (Hartford Public Library)

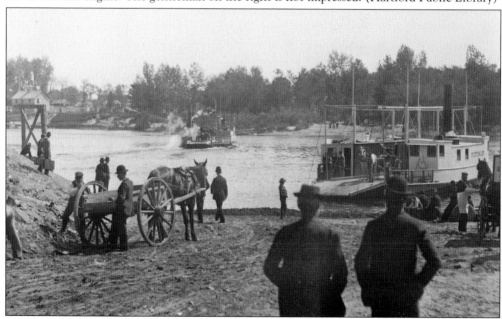

This view of ferry boats at the State Street landing on the Connecticut River was taken in May 1895. Thanks to Riverfront Recapture and their plan to restore the State Street landing, in 1997 we will again be able to reach the river. Forty years of highways and fifty years of the dike blocking the way to the river will be overcome by the Riverfront Recapture group's extraordinary vision, determination, and persistence. (Aetna)

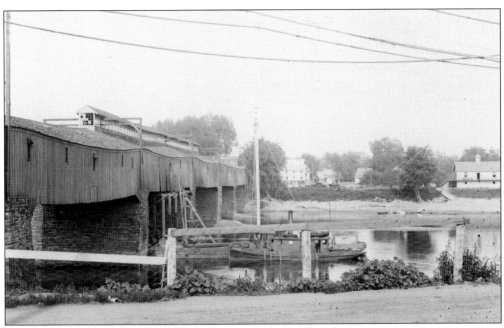

Crossing the Connecticut River from Hartford to East Hartford was this venerable wooden bridge, seen here on August 11, 1894. (Aetna)

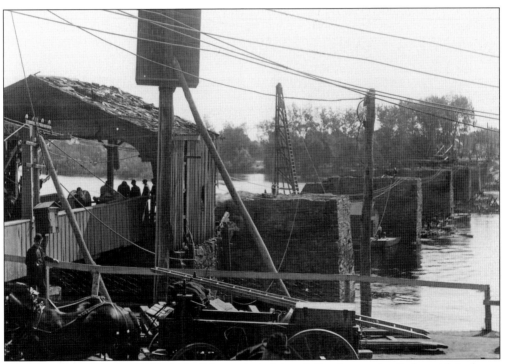

On May 17, 1895, the "Old Bridge" burned, making deliveries to the "other side" almost impossible. A temporary bridge was erected and finally the Bulkeley Bridge was built. Named for Morgan G. Bulkeley—mayor, senator, governor, and the first president of Major League Baseball's National League—the new bridge opened on October 8, 1908, at 10:30 am. (Aetna)

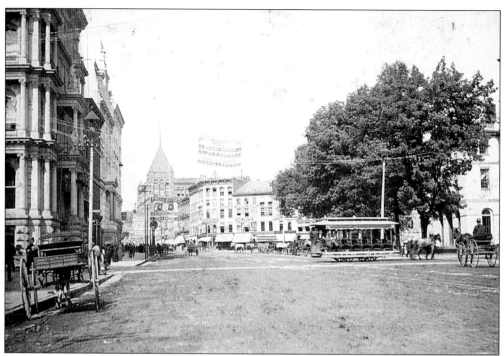

Trolleys were a convenient, safe, and fun mass transit system. At first the trolleys were powered by horses, but on May 12, 1895, at 8:48 am the last horse-drawn trolley in Hartford made its final run up Main Street. As it passed, the first electric trolley began its service on the corner of State and Main Streets. (Hartford Public Library)

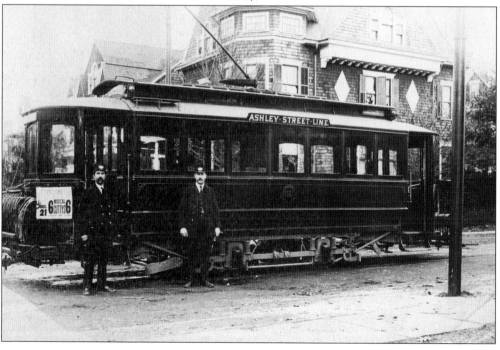

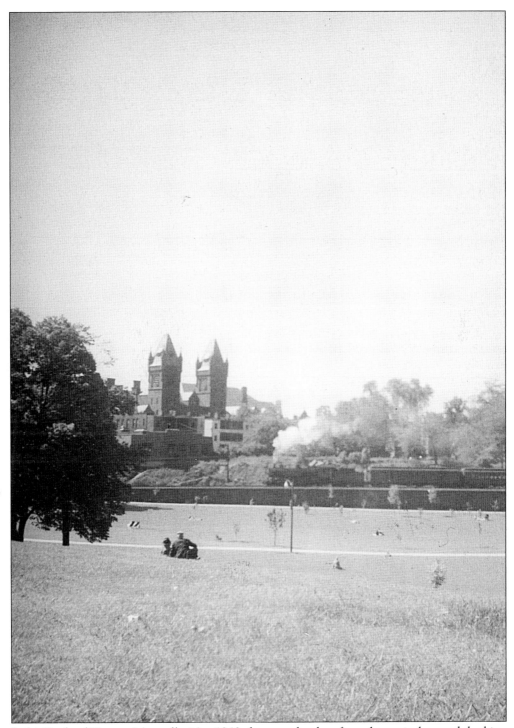

Is this England? Europe? Actually, it's a 1940 photograph taken from the capitol grounds looking west showing the towers of the old Hartford Public High School. When one has vistas like this in the center of a city, one has to question Urban Renewal and all those planners who have razed, highwayed, and parking-lotted what was once a beautiful city. (DeBonee)

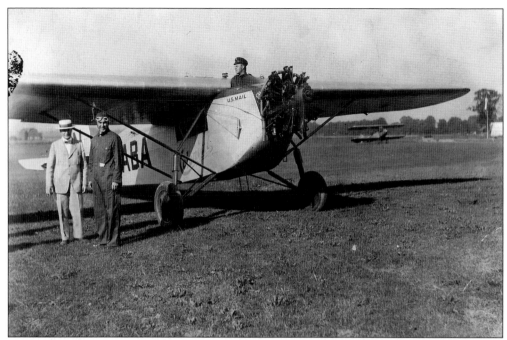

Brainard Airport was named in honor of the then mayor, Newton Case Brainard, and it opened on June 12, 1921. Shown here is the first air mail delivery arriving at Brainard Field on July 1, 1926. (Hartford Public Library)

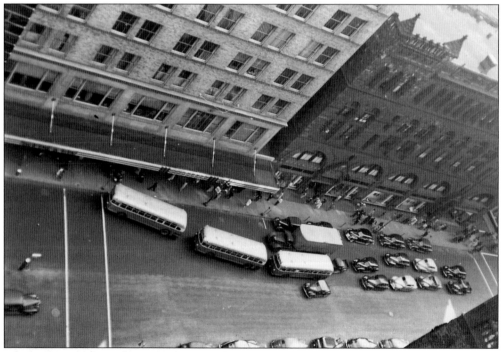

Hartford's city buses have a well-deserved reputation for taking over the roads, regardless of who might be in the travel lane. This September 1942 aerial view of Main Street (by G. Fox's) epitomizes bus arrogance at its best. (DeBonee)

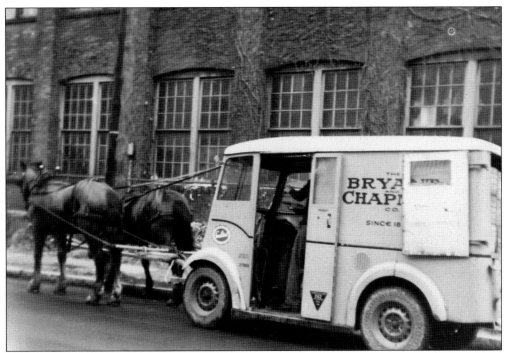

When the engine stalled or gasoline was too dear, some resorted to Yankee ingenuity to keep their vehicle going. This milkman, seen at the Silex Building on Garden Street in 1942, hitched a team of horses to his delivery truck to get the milk out on time. (DeBonee)

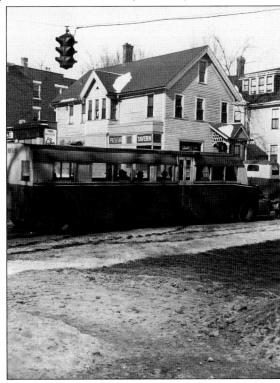

During the war there were trailer buses, complete with a wood stove for heat. This one was seen at the corner of Garden and Mather Streets on January 20, 1945. (DeBonee)

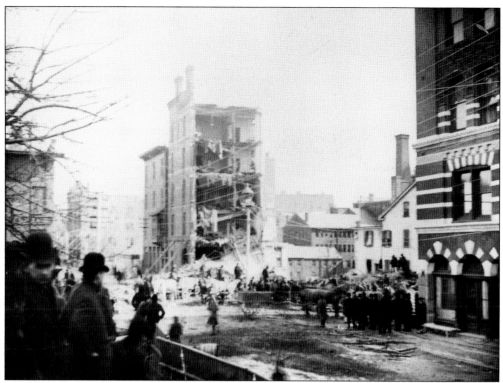

On February 18, 1889, the boiler at the Park Central Hotel on High Street exploded, leveling half of the building. Remarkably, only two people were killed. The explosion spelled the end for the fifteen-year-old business. (Aetna)

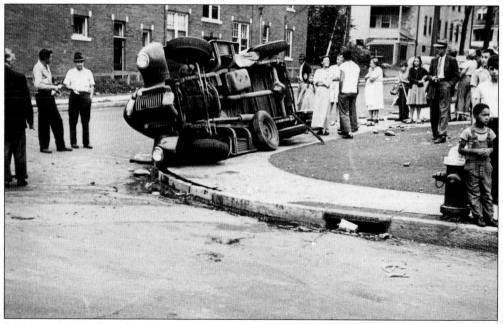

In August 1945, a bread truck, going faster than it should have been, failed to make the corner at the Mather and Garden Street intersection. (DeBonee)

Ten

Disasters

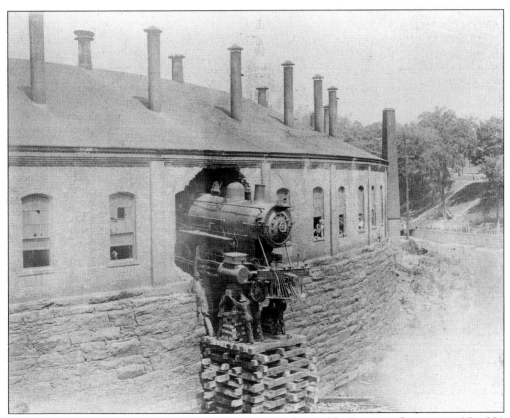

A spectacular mishap made this remarkable photograph possible. Runaway locomotive No. 321 went full steam ahead and burst the wall of the Hartford Roundhouse on July 8, 1905. Such mishaps often cause great corrective measures: in this case, the roundhouse was demolished and replaced in 1909 with Benjamin Wistar Morris's great State Armory. (Hartford Public Library)

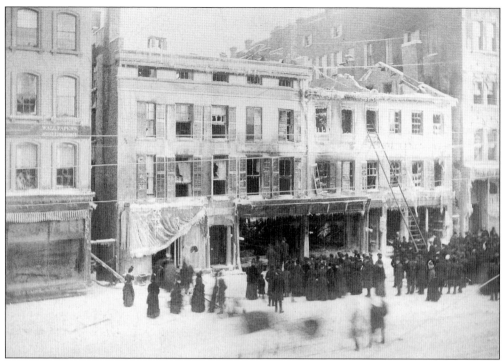

Sawyer's Store was destroyed in a great fire in January 1887. Impressive disasters always draw large crowds. (Hartford Public Library)

On December 24, 1945, an overloaded string of Christmas tree lights caused a fire at the Niles Street Convalescent Hospital that left twenty-one dead. All too often it is fires such as this one and the resulting loss of life that prompt the correction of deficient safety codes. (DeBonee)

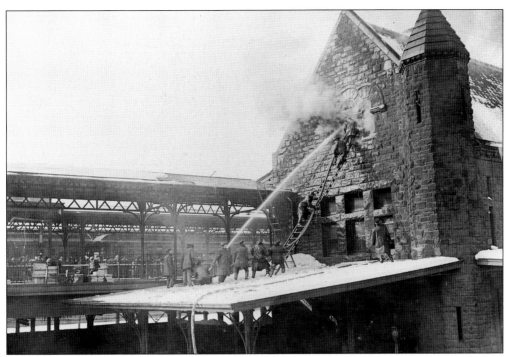

The first Union Station, built in 1849, was replaced in 1887 by a grand structure designed by Shepley Rutan and Coolidge of Boston. On February 21, 1914, a small fire broke out, and when it was finished, the entire station was gone. The present station was rebuilt following the design of Frederick W. Mellor of New Haven. (Hartford Public Library)

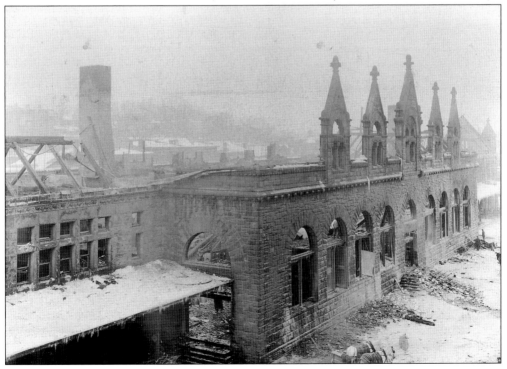

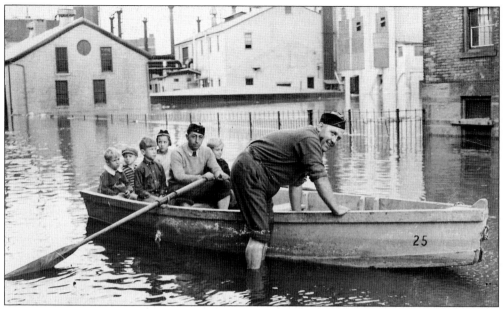

The winter of 1936 produced unprecedented snowfalls, and then to compound matters, the arrival of spring in the second week of March resulted in the 1936 flood. The highest recorded water mark of 29.8 feet set in 1854 was unsurpassed in this year. This photograph shows scouts rowing a group of kids to safety. (Kearns)

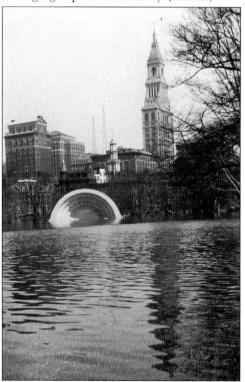 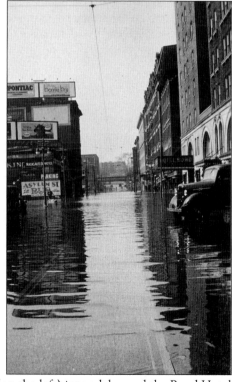

The flood turned Bushnell Park and its bandshell (on the left) into a lake, and the Bond Hotel area of Asylum Street (on the right) into a river. (Hartford Public Library)

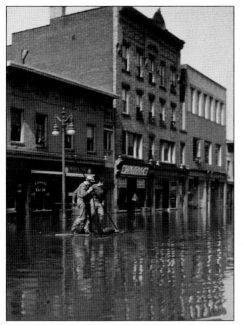

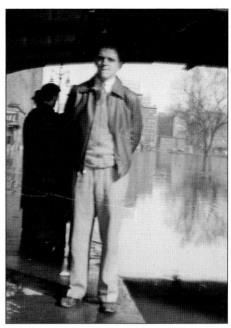

Left: As they often do in such situations, local kids used the disaster as an opportunity to create a Huck Finn adventure.

Right: Robert Brown posing on Asylum by the Railroad Bridge. Beyond Robert, Asylum and Farmington are a river. (Hartford Public Library)

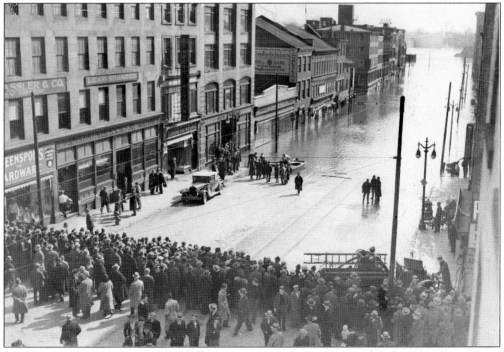

On March 26, 1936, the waters finally began to recede, and a crowd gathered at lower State Street to watch the return of dry land. This flood and the 1938 hurricane would prompt the building of the dike around the city. (Kearns)

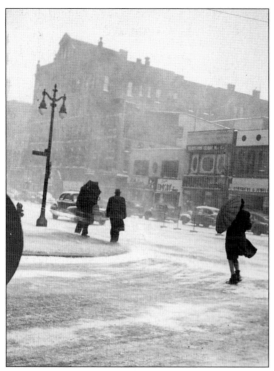

Winter storms and gusty winds are always a problem at the corner of Main Street and Central Row. Here, on February 8, 1945, pedestrians try to navigate in the midst of another storm. (DeBonee)

What began as a small fire discovered during morning mass on December 31, 1956, resulted in the total destruction of the beautiful 1892 St. Joseph's Cathedral. (Kearns)

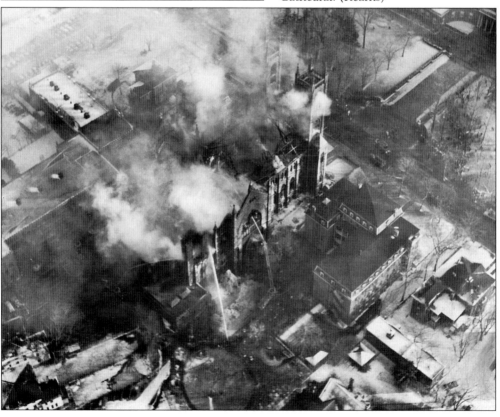

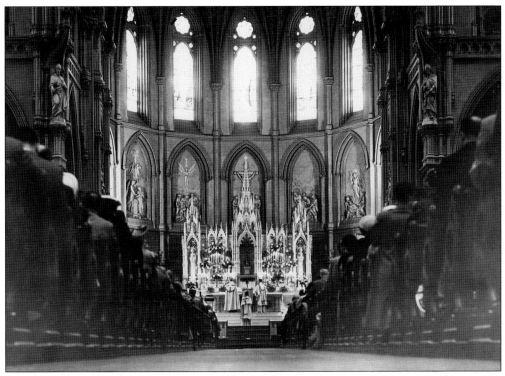

Few photographs survive of St. Joseph's Cathedral before the fire, but here one sees how the great cathedral looked. These show the Great Altar as it looked on Easter Sunday in 1954 (above) and on February 7, 1957 (below). (Kearns)

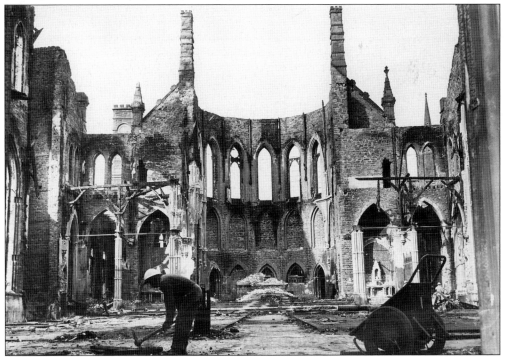

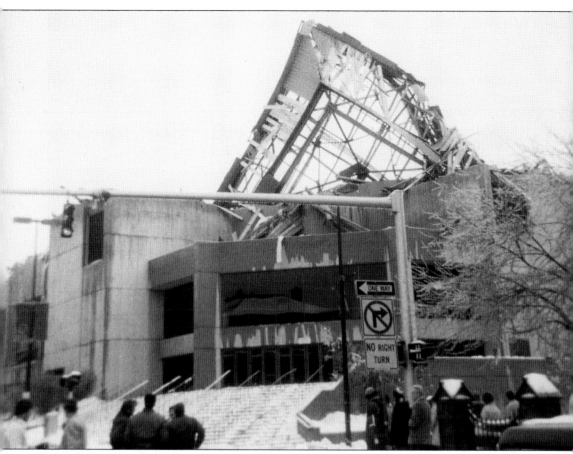

No chapter on disasters would be complete without a mention of the collapse of the Civic Center roof in 1978. The collapse took everyone by surprise, but luckily no one was injured. (DeBonee)

Eleven

The Great War Effort

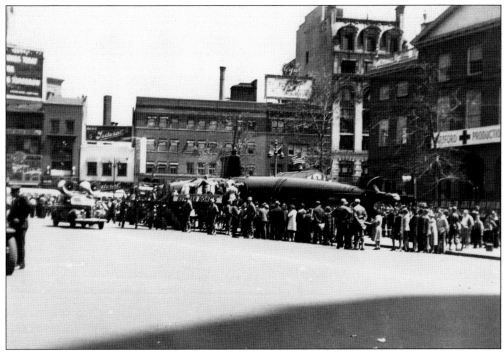

Connecticut citizens embraced World War II with a patriotic spirit that was noteworthy. Equally remarkable were the various "gimmicks" that were used to spur successful bond drives.

When a one-man Japanese submarine was captured in Long Island it was taken on a Bond Drive tour. On May 13, 1943, it came to the Old State House as part of a Bond Drive in Hartford. (DeBonee)

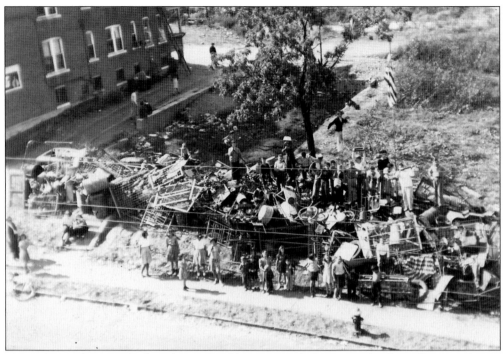

Many charity drives took place during World War II, including some for the collection of scrap metal. Here is a 1942 Garden Street collection awaiting pick up. (DeBonee)

On November 4, 1944, President Franklin D. Roosevelt came to Hartford as part of his whistle-stop campaign. This photograph shows his stop in Bushnell Park and Union Station. (DeBonee)

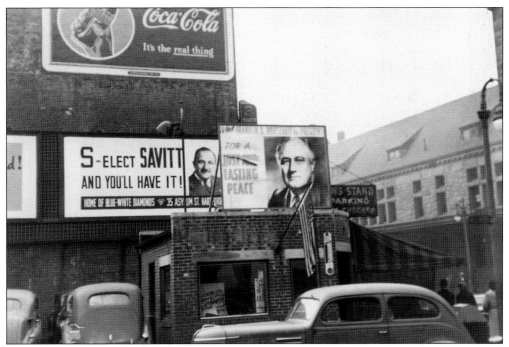

These two legends—P.O.M.G.'s Bill Savitt and President Roosevelt—were both indefatigable campaigners. Savitt ran a jewelry store at 35 Asylum Street, just 35 seconds from Main Street, and was a Hartford booster for over 50 years. (DeBonee)

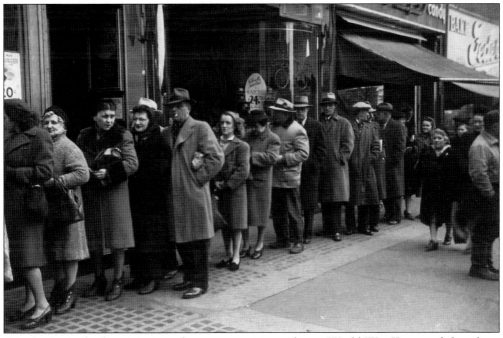

Gas rationing, food rationing, and cigarette rationing during World War II ensured that there was enough to go around. This photograph, taken on February 20, 1945, shows customers lining up on State Street to receive the one pack of cigarettes that they were allowed. (DeBonee)

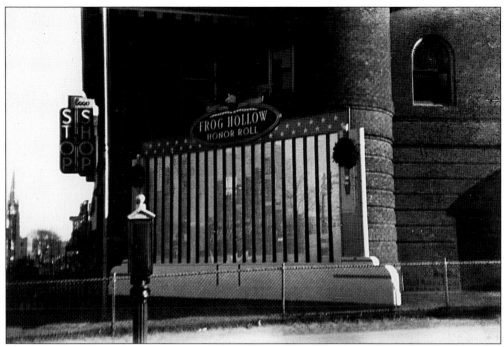

During the war, "Roll of Honor" monuments were erected in every neighborhood to create a record of the sons and daughters who were in service, with special note of those who were killed defending our country. These photographs show: (top) the Frog Hollow Honor Roll; (bottom) the North West Honor Roll by Weaver High School. (DeBonee)

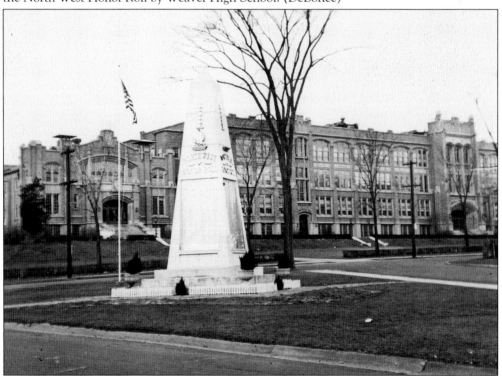

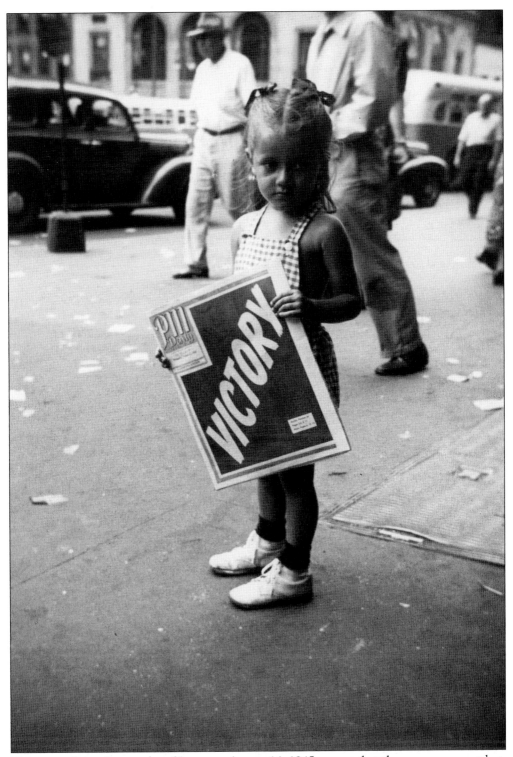

The unconditional surrender of Japan on August 14, 1945, meant that the war was over at last. This extraordinary photograph, taken on Main Street, says it all. (DeBonee)

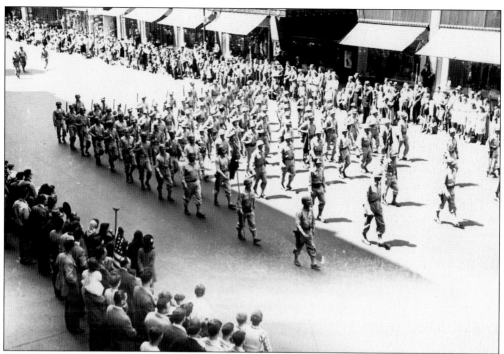

The Memorial Day Parade on May 30, 1946, as the men and women proudly marched on Main Street before a thankful citizenry. (DeBonee)

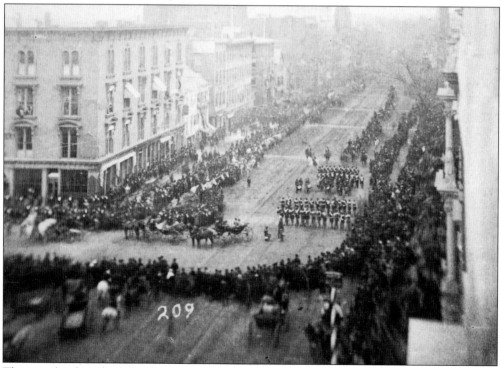

The crowd gathered at Main Street at Central Row in May 1876 witnessed the last old-fashioned Election Day Parade. (Old State House)

Twelve

Parades

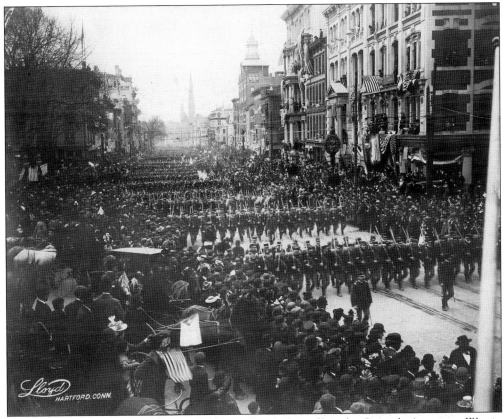

The First Regiment of Connecticut Volunteers marches off to the Spanish American War in 1898. This photograph was taken in front of the Old State House on Main Street. (Hartford Public Library)

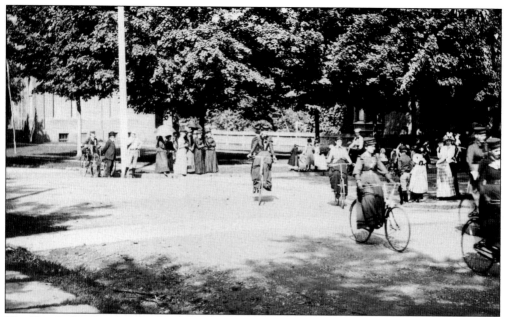

The Hartford Ladies Cycle Club held a much simpler parade in 1892. (Aetna)

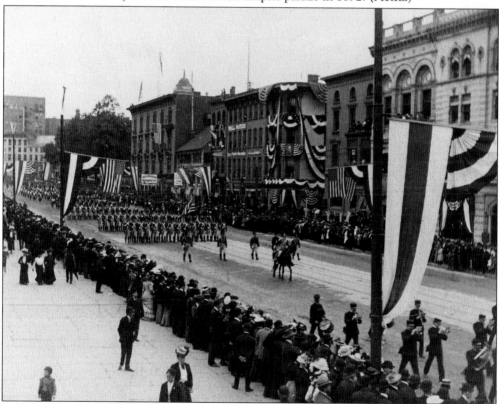

The First Company Governor's Foot Guard, marching on Main Street (south of the Old State House) in either a Memorial Day or Independence Day parade in the 1880s. Note the wonderful buildings on the far side of the street. (Hartford Public Library)

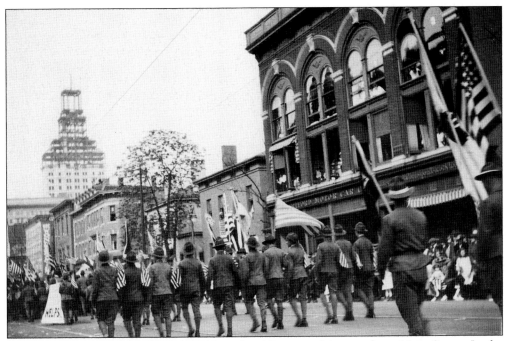

A Liberty Loan parade on May 4, 1918, with soldiers marching north on Main Street. In the background the skeleton of The Travelers Tower can be seen. (Hartford Public Library)

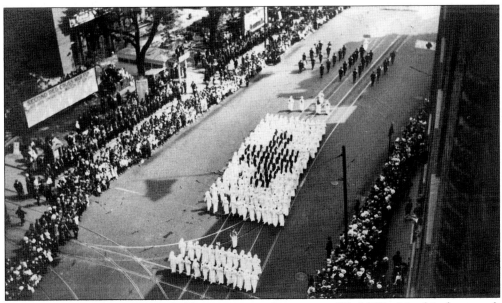

On May 18, 1918, the Red Cross held a massive parade to support World War I. In this photograph the parade is passing by the Old State House on Main Street. (Hartford Public Library)

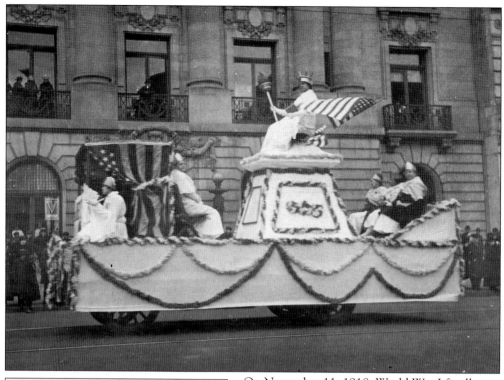

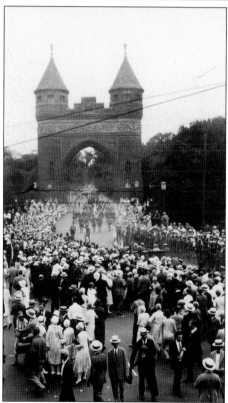

On November 11, 1918, World War I finally ended. To celebrate the event, Hartford held this "End of World War I Parade" seen here in front of Old Aetna Life Building at the corner of Main Street and the Atheneum Square North. (Hartford Public Library)

On July 20, 1927, twenty-five thousand people gathered at Brainard Field to welcome Charles A. Lindbergh to Hartford after his sensational solo flight across the Atlantic. A great parade then proceeded up Main Street into Bushnell Park. Lindbergh had come to Hartford to thank Pratt & Whitney (now United Technologies) for the superb Wasp engine that made the trip possible. (Hartford Public Library)

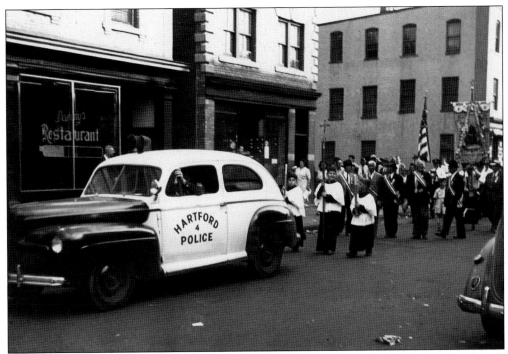

Saints' days were great festival days, usually marked by special parades. St. Lucia's Day—seen here on May 26, 1946, on the east side (Front Street neighborhood)—was one such occasion. A Hartford police car followed by acolytes and grand marshals led the parade. (DeBonee)

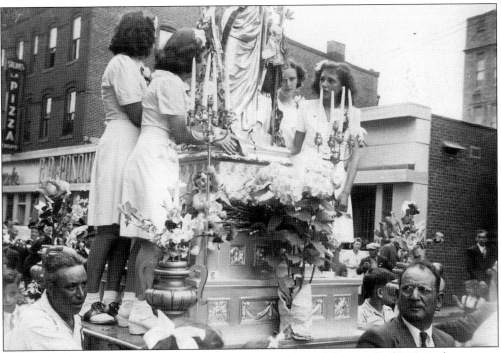

It was a special honor to be chosen to accompany the saint in the parade. (DeBonee)

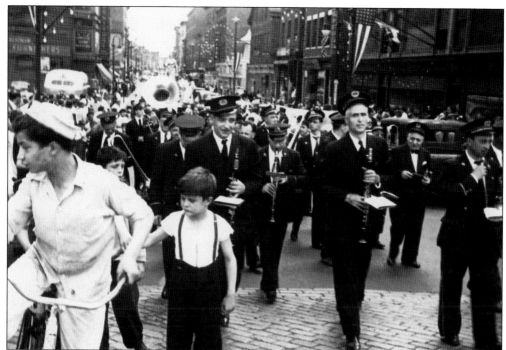

Musicians, floats, and people made these parades great events for the neighborhoods. (DeBonee)

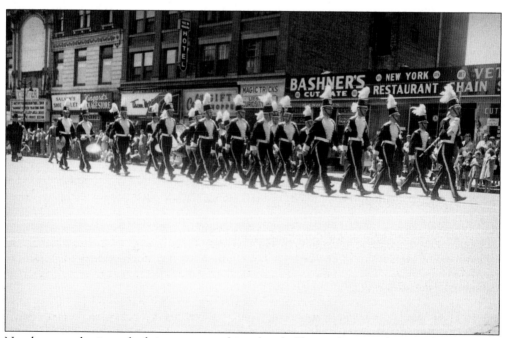

Nearly every business had its own marching band. Shown here is the Royal Typewriter Company's band on Main Street on Memorial Day, 1947. (DeBonee)

Thirteen

Private, Now Public

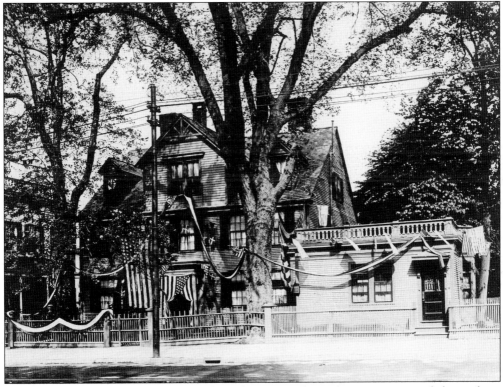

While many of Hartford's old houses have been torn down due to commercial demands or remodeled for offices, a few are now museums which have managed to save some of Hartford's past from the ravages of progress.

The Butler-McCook Homestead stands at 394 Main Street, as it has since 1782. Originally built by Daniel Butler, it has been remodeled over time, but it is still among the very few lone survivors of the fine residences that once filled Main Street. It is shown here festooned for a Memorial Day in the early 1900s. Today the house is preserved by The Antiquarian and Landmarks Society and it is open to the public. (The Antiquarian and Landmarks Society)

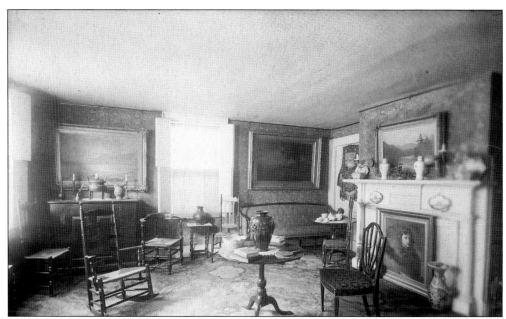

The North Parlor of the Butler-McCook Homestead as it looked in 1910, and as it looks today. The rocker belonged to Daniel Butler, and the painting over the settee is a Bierstadt, purchased by the family as a reminder of a pleasant visit to Italy. (The Antiquarian and Landmarks Society)

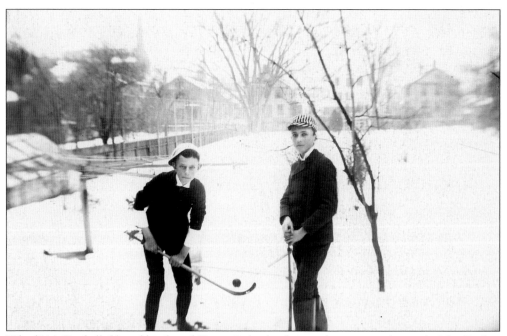

"Shed" McCook (left) and his friend "Jipper" play hockey in the snow in the yard of the Butler-McCook Homestead. Behind them is Prospect Street to the east. This is a rare view of the homes that once filled the street. (The Antiquarian and Landmarks Society)

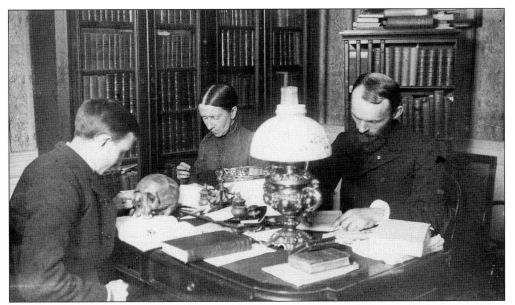

The McCook family gathered on May 17, 1891, in the family library. John B. McCook is studying anatomy (with a friendly skull serving as a bookmark) and his mother, Eliza Butler McCook, is working on her needlework, while his father, Reverend John J. McCook, is composing his report on the homeless. (The Antiquarian and Landmarks Society)

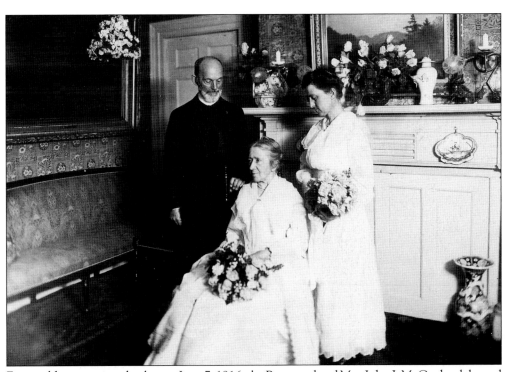

Few could manage it today, but on June 7, 1916, the Reverend and Mrs. John J. McCook celebrated their 50th wedding anniversary. The most remarkable thing is that Mrs. McCook is wearing the very gown she wore on her wedding day! (The Antiquarian and Landmarks Society)

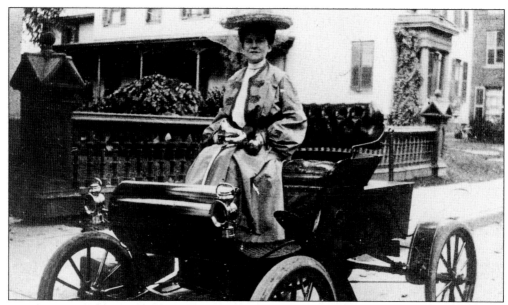

Another property owned by The Antiquarian and Landmarks Society is the Isham House on High Street. This photograph shows Miss Julia Isham in the family's 1902 Oldsmobile in front of the house. In the background we can see some of the Isham's high-style neighbors. When it was decided in the 1950s that I-84 would have to go "through" the house, Miss Julia and her sister, Miss Charlotte, went to a hearing. They testified that they were very sorry to be a bother, but they noticed the highway seemed to go right through their house and, well, they were not going to move. It was their home and the planners would have to redraw their plans. They were sorry to be an inconvenience, but they were not moving. In the end, the thought of evicting two elderly maiden ladies was too much for the board, and the house still stands! (The Antiquarian and Landmarks Society)

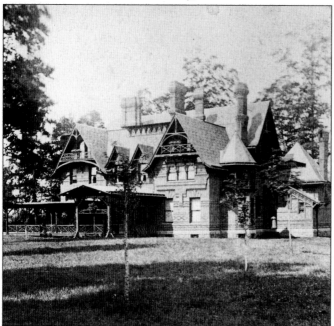

Samuel L. Clemens (or Mark Twain, as most people know him) moved to Hartford to be near his publisher, Elisha Bliss. In 1873 he hired Edward T. Potter to design this nineteen-room, eighteen-fireplace home on Farmington Avenue. This was his most successful period and here all of his major works were written. The house was home to Twain, his wife Olivia, their daughters Susy, Clara, and Jean, and their numerous pets. Fully restored, the house is now open to the public. (The Mark Twain House)

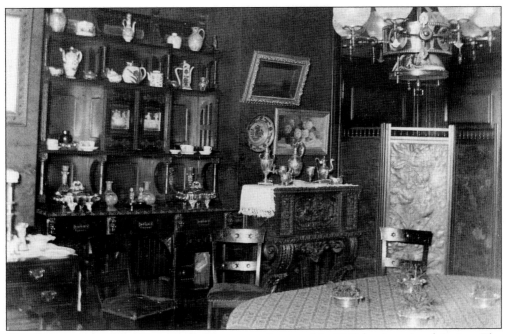

The dining room of The Mark Twain House was decorated in 1881 by Associated Artists. The extraordinary sideboard was purchased by Twain in Boston. Here many of the headliners of the time, including William Dean Howells and Generals Sheridan and Sherman, enjoyed the congeniality of the Clemens' hospitality. (The Mark Twain House)

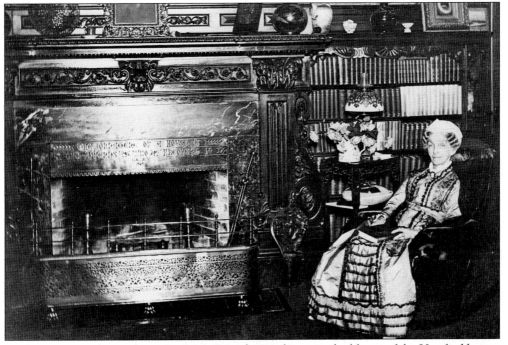

Mark Twain's mother-in-law, Mrs. Jervis Langdon, is shown in the library of the Hartford house. The brass motto above the fireplace was Emerson's sentiment: "The ornament of a house is the friends who frequent it." (The Mark Twain House)

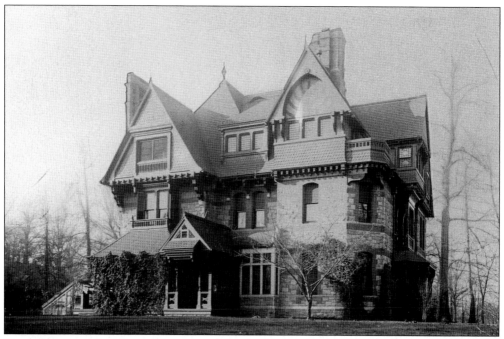

On the corner of Farmington Avenue and Forest Street, next to The Mark Twain House, is the Queen Anne-style Franklin Chamberlin House. It was saved by Miss Katherine Day, who also saved The Mark Twain House and the Harriet Beecher Stowe House from demolition. (The Harriet Beecher Stowe Center)

Harriet Beecher Stowe lived in this house on Forest Street from 1872 until her death in 1896. Mrs. Stowe was an extraordinary person whose talents and influence are only now being fully appreciated. Her house is fully restored and open to the public. (The Harriet Beecher Stowe Center)

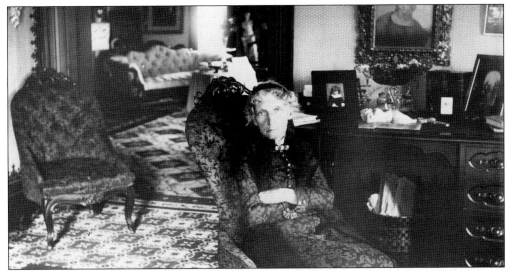

Harriet Beecher Stowe in her front parlor on August 18, 1886. She is surrounded by personal items which were mostly gifts from a world of admirers. The house has been carefully restored and most of the pieces shown here are again in their place, a century later. (The Harriet Beecher Stowe Center)

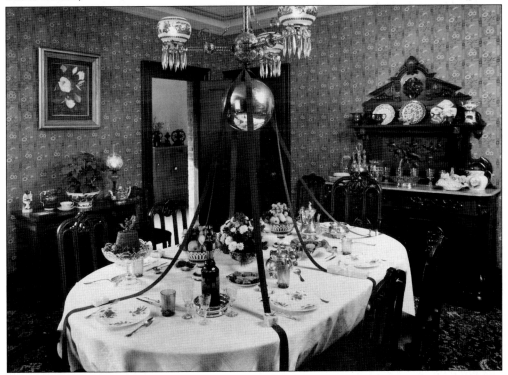

Christmas in Connecticut was a most festive time, and during the Victorian era it took on legendary proportions in Hartford and beyond. Both the Mark Twain and the Harriet Beecher Stowe Houses decorated for the season. Shown here is Mrs. Stowe's dining room with the great mercury glass ball with ribbons leading to presents for all the diners. (The Harriet Beecher Stowe Center)

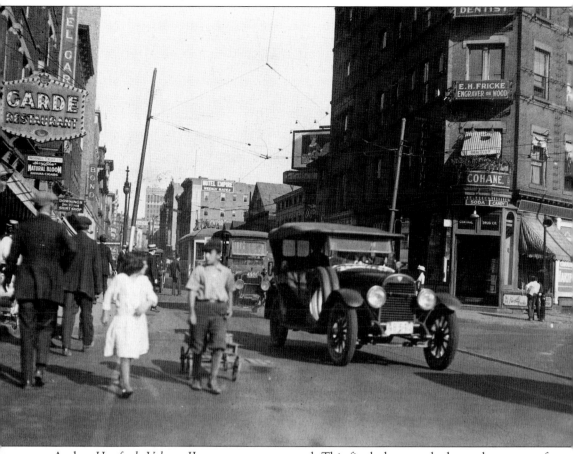

And so *Hartford: Volume II* must come to an end. This final photograph shows the corner of Asylum and Ford Streets. The Garde Hotel is gone, having been replaced by Capitol Center. The building on the corner that features Mr. Fricke (dentist), an engraver on wood, and the Central Drug Co. would become the site of the Statler Hilton and, since its demolition on October 28, 1990, a parking lot. Of special interest is the kid with the wagon, one of many such youngsters who would walk around the city running errands or carrying packages for some pocket money. (Hartford Public Library)

I hope you have enjoyed *Hartford: Volume II*. If you have or if you know of other wonderful pictures, please let me know—there's always room for another book!

Wilson H. Faude
Executive Director
Old State House
800 Main Street
Hartford, CT 06103